selfportrait.map

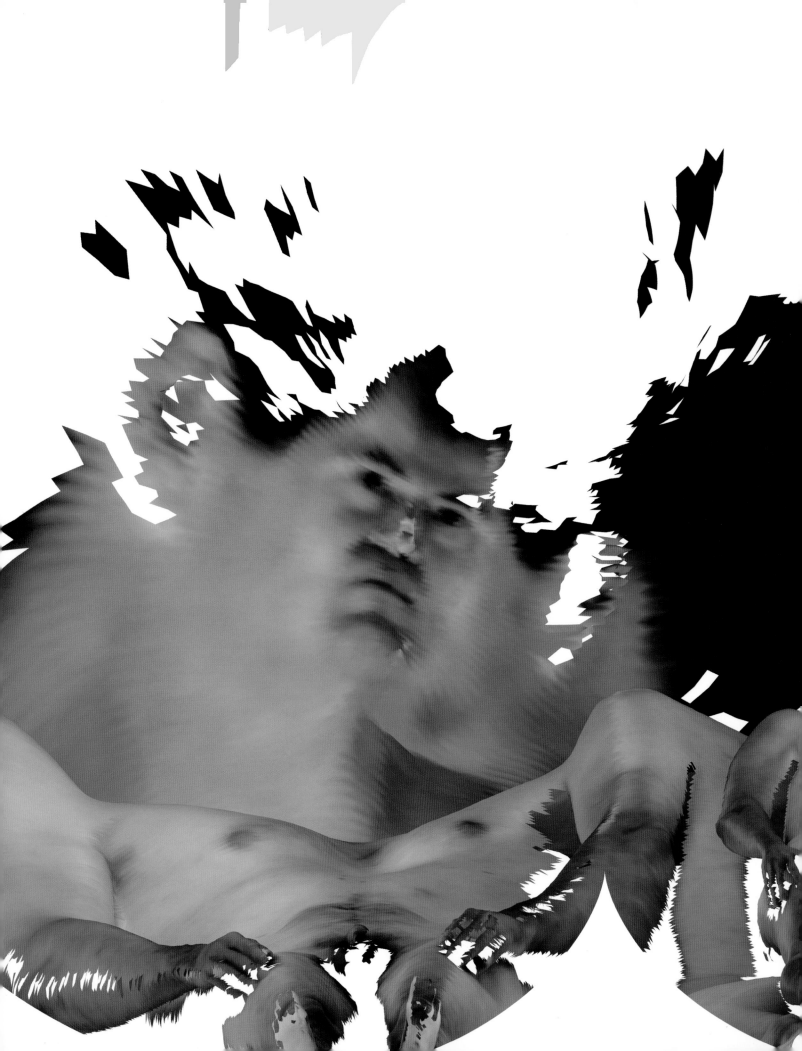

LoCurto/Outcault

selfportrait.map

Lyman Allyn Museum of Art at Connecticut College

MIT List Visual Arts Center

University of Washington Press, Seattle & London

Lyman Allyn Museum of Art at Connecticut College
625 Williams Street
New London, CT 06320
860.443.2800

MIT List Visual Arts Center
20 Ames Street
Cambridge, MA 02139
617.253.4680

The exhibition tour was organized and facilitated by Pamela Auchincloss, Arts Management, New York.

MIT List Visual Arts Center, Cambridge, MA
February/March, 2000

Selby Gallery
Ringling School of Art and Design, Sarasota, FL
September/October, 2000

Hatton Gallery
Colorado State University, Fort Collins, CO
January/February, 2001

Lyman Allyn Museum of Art at
Connecticut College, New London, CT
September/October, 2001

Mary and Leigh Block Museum of Art
Northwestern University, Evanston, IL
January/February, 2002

Fort Wayne Museum of Art
Fort Wayne, IN
April/May, 2002

cover: Plate 11 (detail)
Conformal Guyou L2sph(8/6)7_98

Photography credits:
Unless otherwise stated the photographs are by the artists.
Self Portrait and *Self Portrait* (detail) by Robert Wedemeyer
Crossings and *Crossings* (detail) by David Famiglian

Designed by Katy Homans

Printed in Hong Kong by South China Printing

Catalog distributed by
University of Washington Press
P.O. Box 50096
Seattle, WA 98145
206.543.4050

ISBN 0-295-97934-8
Library of Congress
99-68964

Contents

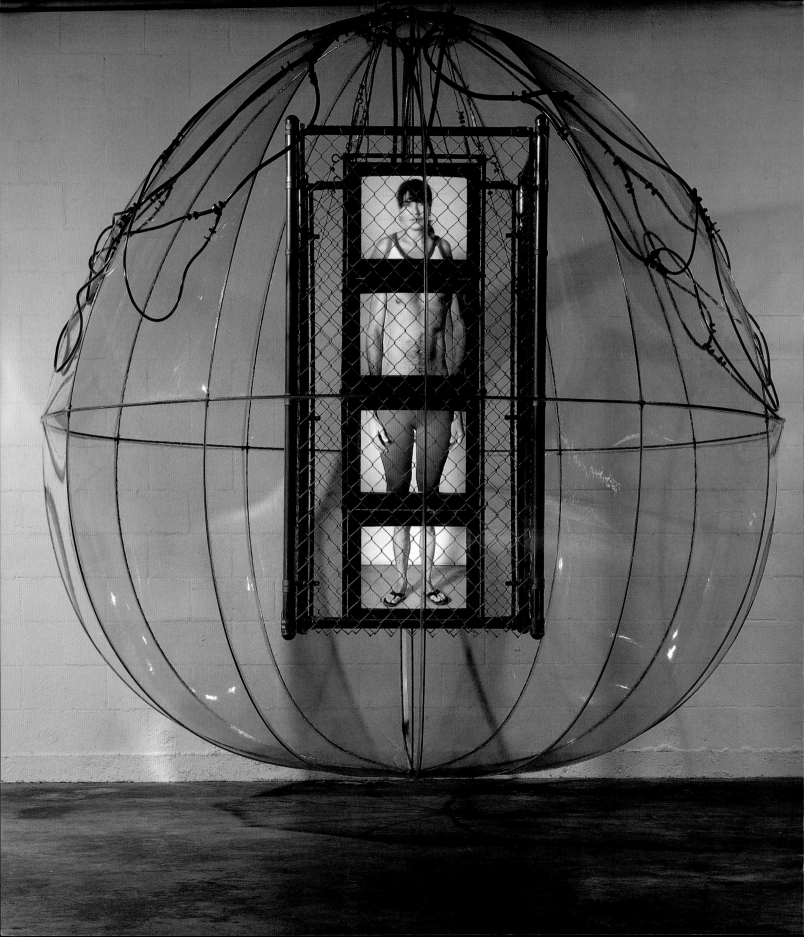

Lilla LoCurto and William Outcault: from *Self Portrait* to *selfportrait.map*

Helaine Posner

Artists Lilla LoCurto and William Outcault created their first collaborative work, an interactive video-installation titled *Self Portrait* (illus. 1), in 1992. This work was conceived and executed during the rise of the AIDS epidemic and sprung from the artists' desire to understand the nature of a disease that posed enormous threats to the physical health and psychological stability of the individual and, by implication, to society as a whole. They chose images of the fragmented body, their own and others, as a metaphor for the assault on the integrity of the private and public body in times of crisis.

After the death of a friend from AIDS the artists naively wondered whether a person could be placed in a germ-free environment, such as a protective bubble, and survive. They soon learned that an immune system compromised by HIV or AIDS is vulnerable to opportunistic infection both from within the body and from without. Lacking the protection of a healthy immune system the viruses and bacteria long contained within our body, as well as those contracted externally, will destroy us. The artists' recognition of this devastating truth prompted them to create a work that underscores the universal nature of this threat as it heightens our compassion for and identification with those afflicted.

This interactive, multi-media installation centers on a transparent globe measuring nine feet in diameter that is meant to symbolize the human body, or more specifically, the womb. The willing participant sits in a chair facing the suspended sphere and places his or her fingers in a pulse oximeter sensor that picks up his or her pulse. The sensor interfaces with an audio device that amplifies the pulse, filling the space with the sound of one's heartbeat. This device also activates a pumping system, synchronized with the pulse, that circulates a dark-red blood-like fluid through a network of plastic tubes attached to the exterior of the bubble. A video camera mounted in front of the chair transmits the viewer's face to the top video monitor in a stack of four that are suspended within the transparent sphere. The monitors are caged by a chain link fence representing the body's failed immune system. The column of monitors presents an eerie composite body or a video version of the Surrealists' "exquisite corpse."[1] Below the viewer's head and shoulders, first the torso, then the pelvis and thighs and finally the legs and feet of almost forty individuals of both genders, various races and ages, clothed or naked appear on the screens to create a constantly changing body from these multiple fragments.[2]

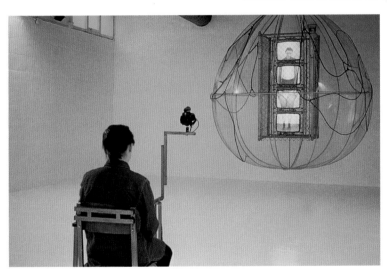

1. *Self Portrait*, 1992
Video mixed media installation
Installation: 10' x 22' x 32'

Self Portrait (details), 1992

Seeing our own head mounted on the bodies of "everyman" visually draws us into an intimate encounter with a highly diverse collection of strangers. The effect is both provocative and unsettling as our identity becomes linked to anonymous others, both literally and metaphorically. At a time when AIDS prompted great fear, and groups considered to be at the greatest risk suffered exclusion, *Self Portrait* expressed the artists' belief that we are all vulnerable to the physical, social and psychological challenges confronted at the end of the twentieth-century, and, therefore, each one of us is at risk. Our mutual

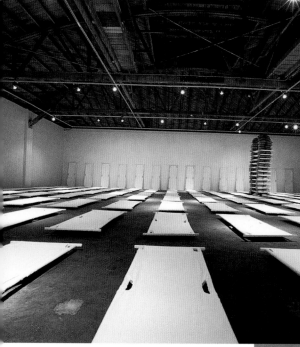

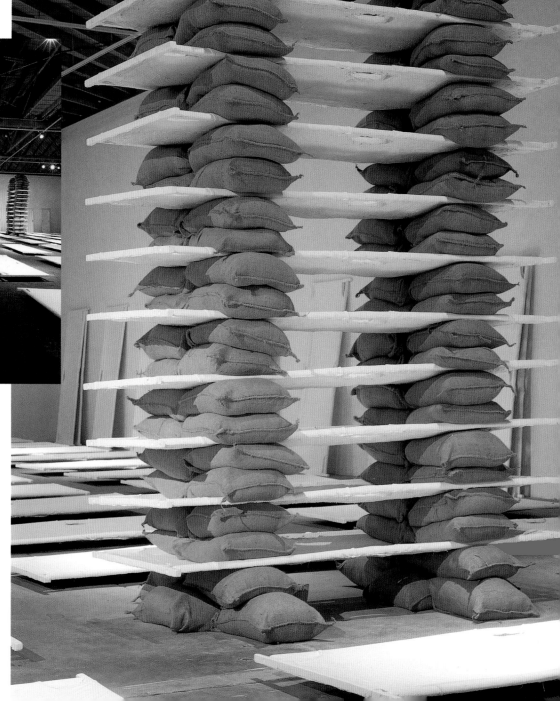

2. Lilla LoCurto
Crossings, 1991
Plaster and sandbags
Installation: 70' x 75'

isolation within this fragile membrane, which symbolically courses with our blood in a space that beats with our heart, viscerally implicates us in the lives of others. LoCurto and Outcault's installation is not simply a self-portrait, it is a portrait of each of us as an integral part of a larger community.

After graduating with Master's of Fine Arts degrees in sculpture from Southern Illinois University in 1978, LoCurto and Outcault who are husband and wife, pursued independent artistic careers. LoCurto built room-sized installations of found and sculpted objects to make political or moral statements. In 1991, for example, she created an exhibition that included rows of bombs, helmets and white stretchers that powerfully expressed her anti-war sentiments (illus. 2). The repetition of elements and use of a grid arrangement lent a formal grace to her work. Outcault created abstract sculptures from such materials as wood, plaster, fiberglass and lead. His work suggested organic forms such as eggs, breasts or cocoons while remaining essentially non-referential (illus. 3). The use of repetition and the grid, typical of Minimal art, also played a role in his sculpture. The artists regularly gave each other feedback, offering direct and honest

3. Bill Outcault
Untitled, 1991
Fiberglass and cedar
112"x 56½" x 37"

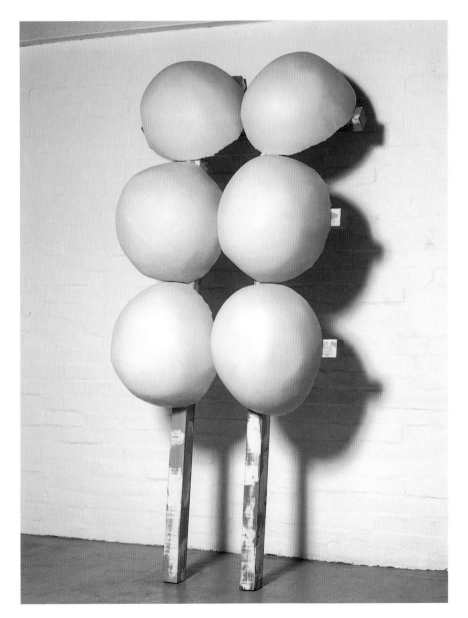

critiques of each other's work. Conceptual input evolved into actual collaboration when they decided to pool their resources to meet the demands of building *Self Portrait*. They found that collaboration "put us more on the edge,"[3] and that together they were able to be more experimental and take greater risks in their work.

In 1994, the artists' ongoing interest in the fragmented body as a site of social conflict resulted in a series of works exploring the multiple and highly charged meanings of the female breast. LoCurto and Outcault drew upon art history, popular culture, modern medicine and contemporary texts to look at our culture's continuing fixation on this body part. In their three-part installation

titled *Sharp Appetites*, comprised of *Fleshbags*, *Lodestones* and *Pinnacles of Desire*, they examined the breast and the female body as a commodity defined and distorted by our patriarchal culture.

In *Fleshbags* (illus. 5) plastic bags containing a clear gel or milky fluid hang from racks of meat hooks. Within these breast-like sacs color photographs of iconic nudes from the history of art such as the ancient *Venus of Willendorf*, Botticelli's *The Birth of Venus* and Manet's *Olympia* are juxtaposed with recent images from pornographic magazines and an advertisement for a motorized doll. Although they range from the exalted to the debased and date from pre-history to the present, these nudes are displayed as equals. Each represents the sexually desirable female body offered for the male gaze. In contrast to the fantasy, a collection of poems by Robert Haas, Frederick Seidel and Alicia Ostriker, also placed in the gel-filled bags, poignantly describe the reality and loss of mastectomy.

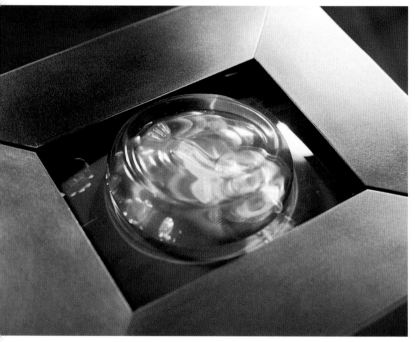

The artists selected a graphic and compelling object to examine contemporary society's perception of female beauty or sexuality as focused on the breast. They used the silicone breast implant to signify how the pressure to conform to an ideal may be so great that the natural function of the breast and the overall health of the body are placed in jeopardy. The dangers then associated with ruptured implants such as immune system disease, nervous system disorders and rheumatoid arthritis, put medical concerns at the forefront of

above:
4. *Sharp Appetites:
Pinnacles of Desire*, 1994
Steel, TV monitors, silicone
breast implants, video and VCRs
40" x 58½" x 12¾"

opposite:
5. *Sharp Appetites: Fleshbags*,
1994
Steel meat hooks, plastic bags,
gel and transparencies
(Detail of installation)

discussions of this work. *Sharp Appetites*, however, addressed a range of issues related to the body and gender. The installation titled *Pinnacles of Desire* (illus. 4) included four pairs of video monitors with screens facing upward that were encased in steel boxes mounted on and joined by metal rods. Each screen was covered by a clear silicone breast implant. The distorted images as seen through the gel included breast augmentation surgery, babies nursing, men and women engaged in sexual acts, clips of Leni Riefenstahl's Nazi film *Triumph of the Will* and television commercials for beauty products and body-building equipment, among others. These images, and the music and poetry on the accompanying audiotapes, were at turns provocative, humorous, ironic or beautiful. Each pair of videotapes presented a dialogue on the cultural significance of the breast as an erotic object, a source of nourishment, a sign of femininity or of conformity.

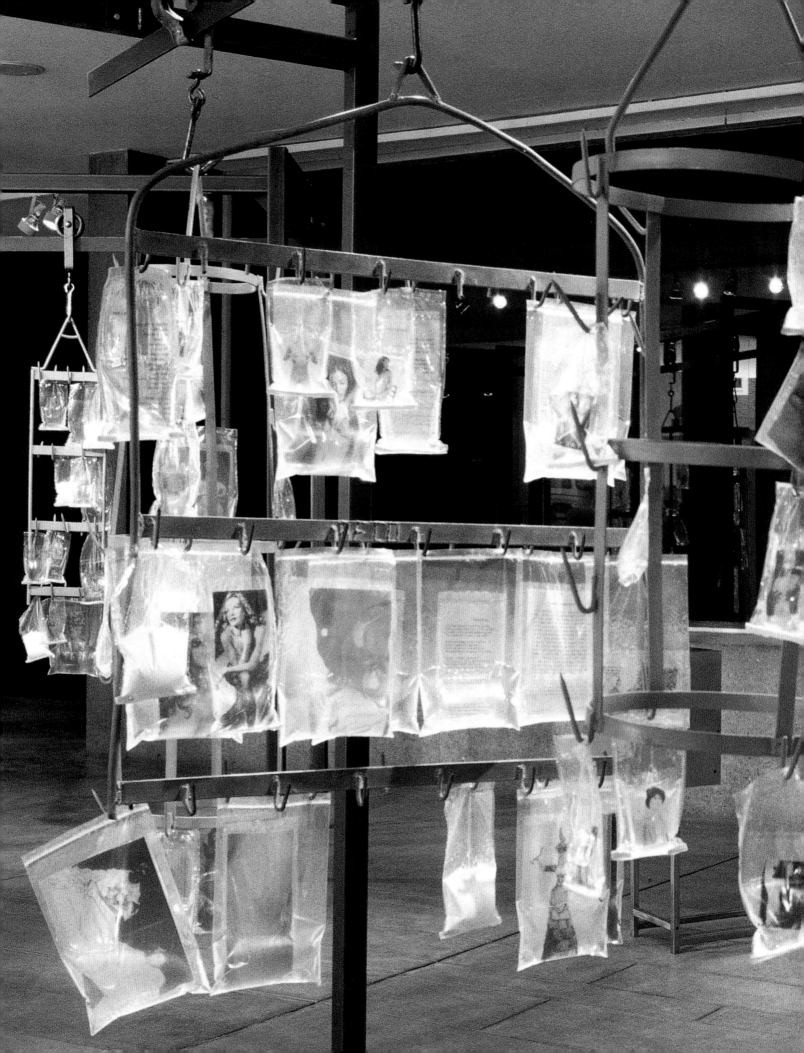

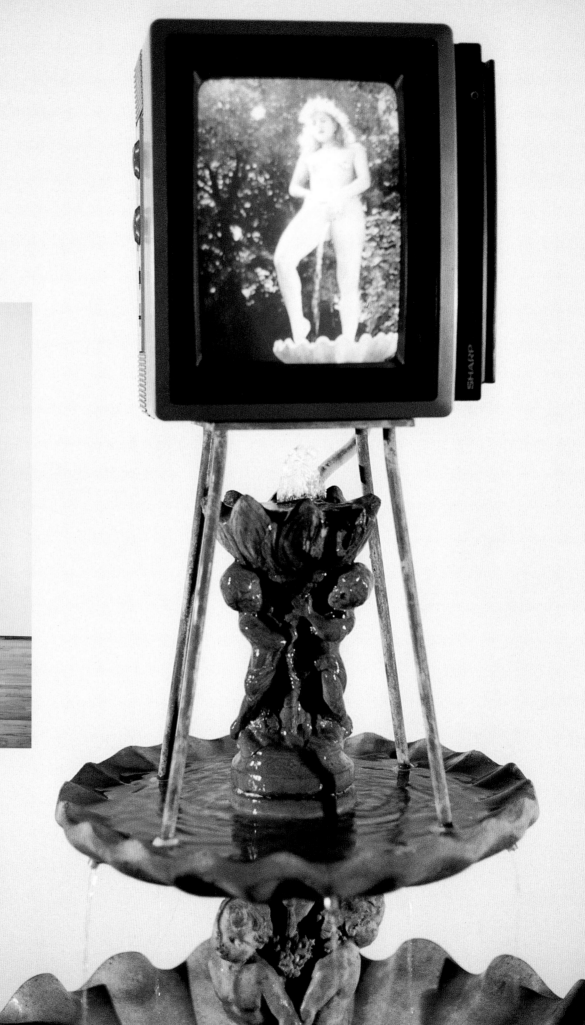

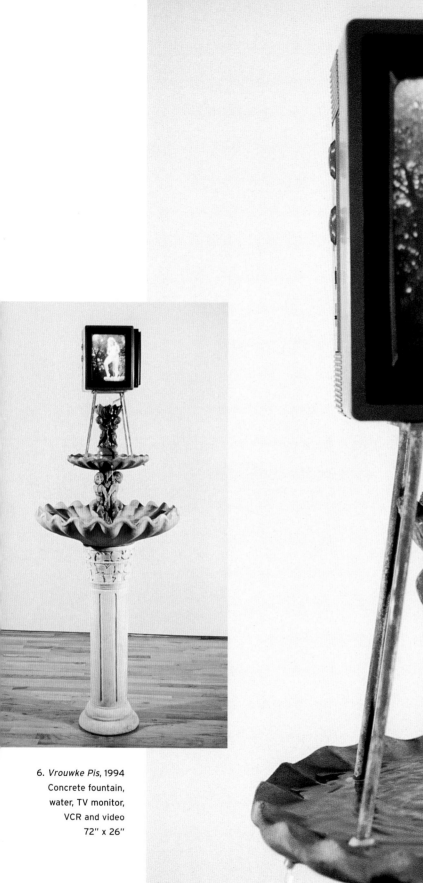

6. *Vrouwke Pis*, 1994
Concrete fountain,
water, TV monitor,
VCR and video
72" x 26"

Sharp Appetites vividly revealed the contradictory and competing interests society projects onto the intimate body.

LoCurto and Outcault approached the politics of gender in a lighter vein in *Vrouwke Pis*, 1994 (illus. 6), a satire of a popular fountain in Brussels called *Mannekin Pis* that features the statue of a cherubic little boy peeing into the water. The artists acquired a working fountain and in their version replaced the figure of a little boy with a videotape of an attractive nude woman cheerfully peeing into the fountain on a beautiful day. The woman performing this private act is on public display yet she remains as unselfconscious as the child. She is, of course, seen in a very different light. While a little boy so exposed is viewed as natural and cute, a woman so positioned immediately takes on erotic connotations bordering on the obscene. By changing the age and gender of the subject in *Vrouwke Pis* (woman pees), the artists highlight the stark contrast in our cultural readings of an identical bodily function.

In their next group of sculptures, the artists stepped back from direct political and social commentary to provide a gentler meditation on the vulnerable body. To do so they chose a childlike figure, the so-called bean boy, to reflect upon a time of innocence. The *Bean Boys*, 1995 (illus. 7) are five soft, pale blue rubber figures suspended on a simple garden trellis. They are rudimentary beings, consisting of only an oblong-shaped torso and head, made to softly "breath" by means of a tube that links them and pumps air through their limbless forms. In a related work the bean boy lies in a schematic bed or crib, its breathing more pronounced and posture more defenseless (illus. 8). The delicate expression and embryonic state of the bean boys is reminiscent of Kubricks' ethereal "Star Child" from the film *2001: A Space Odyssey*. These creatures, however, are more earthbound. Like a butterfly about to emerge from its cocoon, a baby to be born from its mother's womb, or a seed beginning to sprout, they are poised on the brink of life.

These incipient beings are in a tender state. They remind us of the purity of childhood, a time before the complexities of late twentieth century life and the manipulative power of the media pervade our daily existence. It is of course a protected and fleeting moment, one that becomes even more transitory in the information age. The artists, however, do not express a yearning for a simpler past, nor do they eschew technology in their art making or their lives. They are merely conscious of the melancholy fact that with every gain there is also a loss. As our culture advances and our experience becomes more virtual than real, it is increasingly difficult to remain attuned to our humanity. We lose our innocence and, with that, part of our selves.

About 1996 the artists decided to return to the self-portrait, working with digital technology to radically reconfigure one of art history's most time-honored subjects. This process required over two years of research and development supported by the Massachusetts Institute of Technology and the Lyman Allyn Museum of Art, access to a whole body scanner located at the Natick Soldier Systems Command in Massachusetts and the commitment and collaboration of a computer scientist and two mathematicians.[4] Employing a full-body scanner, traditional cartography software and another software to make the two compatible, the artists began to produce photographic self-portraits as map projections. LoCurto and Outcault's stated goal was to "deconstruct the human form in terms of its volumes, rendering it in absolute two-dimensions."[5]

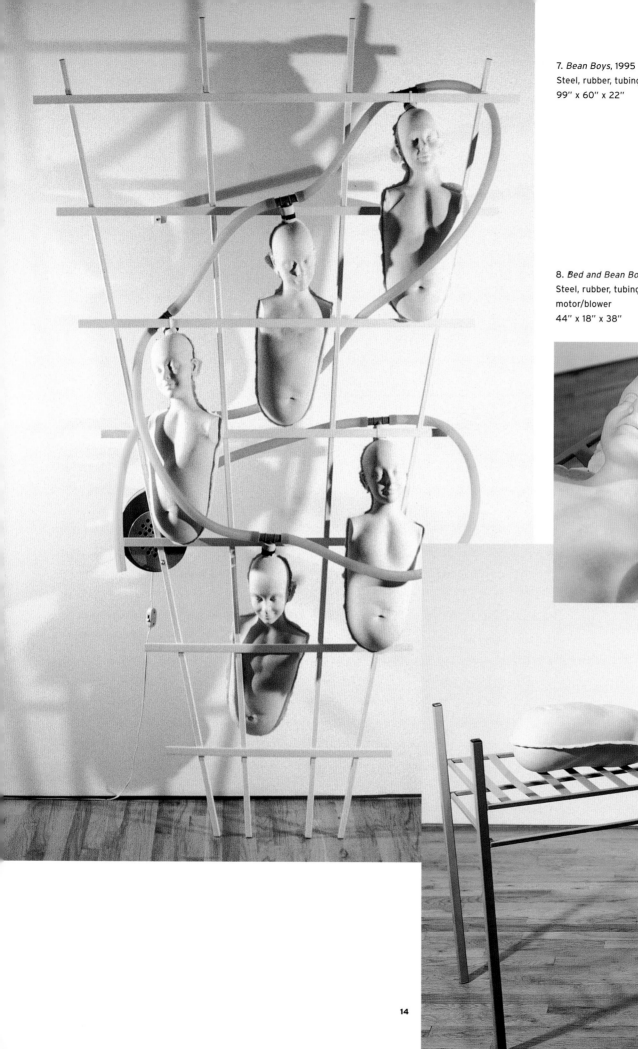

7. *Bean Boys*, 1995
Steel, rubber, tubing and motor/blower
99" x 60" x 22"

8. *Bed and Bean Boy*, 1995
Steel, rubber, tubing and
motor/blower
44" x 18" x 38"

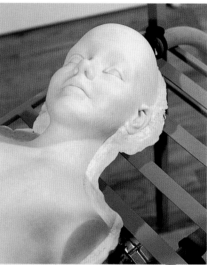

They go on to explain, "a projection, in cartographic terms, is the transference of details from a three-dimensional object, such as the earth, onto a single plane, such as a map. There are any number of projections possible, each having its own particular set of distortions and truths. . . . The translation of a three-dimensional form, particularly the human figure, into a two-dimensional painting or drawing has been a traditional concern of artists for centuries, and experiencing a three-dimensional object at once in its entirety, the notion of simultaneity, was a primary goal of the Cubists. By employing a cartographer's mathematics and with the aid of a computer and a large three-dimensional scanner we now have the potential to visualize the human form in two dimensions in an entirely new way. This project also contains an element of abstracted violence in the presentation of the figure as a hide or skin to be displayed on the wall. This violence, however, is binary, virtual and subdued; the resulting images are so flat they seem disconnected from the implied act."[6]

LoCurto and Outcault's *selfportrait.map* explores the topography of the body in a series of works that range from the identifiably figurative to the nearly abstract and from the horrific to the sublime. Pictured alone or paired in works measuring up to eight feet across, the artists used projection systems as familiar as Mercator or as obscure as Conformal Guyou to manipulate their images to stunning effect. Their range of choices was practically unlimited. They decided to focus on the features that distinguish the body's surface such as the face, hands, feet and breasts, and selected particular mapping systems to achieve their desired degree of abstraction or distortion. The artists included graticules, the network of lines of latitude and longitude upon which a map is drawn, in certain works to create a more coherent composition.

Even images of the digitally deconstructed body may relate to historic depictions of the human form. In *Kharchenko-Shabanova BS1sph (8/6)7_98* (plate 9), a photograph of William Outcault is symmetrically unfolded and splayed out across the picture's surface, his body seemingly suspended in space. The central focus on his clasped hands and the tension between a body that appears to be drawn together and pulled apart brings to mind Michelangelos's *Creation of Adam* from the Sistine Chapel. In this iconic painting, God descends from the heavens to the earth as life miraculously flows from His hand to the hand of man. In breaking up the body into separate spheres and linking those spheres with extended arms, LoCurto and Outcault's photograph echoes this electric moment. Stylistic elements of the Baroque can be seen in *selfportrait.map* in the deep rich colors, strong contrast of light and shadow or chiaroscuro and curiously painterly look of these large-scale photographs.

LoCurto and Outcault's unconventional self-portraits are not intended to be revealing studies of their individual identities. Instead, they prefer to use their bodies more objectively, as the raw material for creating work that explores an expanding range of concerns. In *Self Portrait*, 1992 they combined videotaped fragments of themselves and numerous others with video feeds of the viewer's face to achieve a sense of identification between the individual and society. With the aid of advanced technology in *selfportrait.map*, 1998 the artists have manipulated their disembodied forms more dramatically to create self-portraits that encompass the earth and even the cosmos. They have merged themselves with the world.

LoCurto and Outcault's virtual merge has broad and varied implications. The artists' digital deconstruction of their three-dimensional bodies and digital reconstruction of them in two-dimensions does subtle violence to the human figure. The bodies represented are, in fact, merely hollow forms or empty shells since the full-body scanner can read and photograph only the surface of an object, in this case the skin. Subjected to the additional distortions of the various mapping systems, the integrity or wholeness of the body is even further damaged. In *B.S.A.M. BC2sph(8/6)7_98* (plate 4), for example, Outcault's body seems to dissolve before our eyes. His head and crossed arms, seen on the right, are attached to an amorphous, apparently flayed skin that bears little relation to the human figure. In works like *Urmayev III L3sph(8/6)7_98* (plate 17) the virtual violence is more aggressive as LoCurto's body looks like it has been torn into fragments. These parts suggest islands of disembodied flesh or landmasses adrift in an indeterminate white sea. The artists' ruptured forms also bring to mind the potentially destructive force of the earth's shifting tectonic plates.

While merging the individual with the world can connote a frightening disappearance of the self, it may also be read in another way. This fusion may suggest a sense of continuity between ourselves and the cosmos or the possibility that we are all connected to something greater. In *B.S.A.M. BL1sph(8/7)7_98* (plate 1) LoCurto and Outcault's bodies are essentially a pair of rounded shapes floating in mid-image. The inclusion of curved and circular graticules reminds us of mapping the globe and reinforces the suggestion of a gravitational pull between their two hovering bodies. The artists' forms are like the planets revolving in an infinite and eternal space. With these unique and startling hybrids the artists have recreated the cosmos as themselves. *selfportrait.map* may be understood as a utopian vision of a unified and harmonious universe.

With hope may come uncertainty; darker interpretations of this work are also possible. Are the artists' bodies serenely blending with the cosmos or are they disappearing into an existential void? A work as abstract as *Mercator BL1sph(8/8)7_98* (plate 6), in which the blur of their expressionless faces and extremely foreshortened bodies circle around a vacant black and white space, may imply an absurd or irrational world where we simply drift alone. In *selfportrait.map* LoCurto and Outcault have succeeded in creating a series of images that are simultaneously compelling and disconcerting. Based in the flesh, they have employed new technologies to make objects that LoCurto thinks of as "artifacts of an idea."[7] The artists' great strength lies in their ability to look boldly to the future as they continue to explore one of humankind's most persistent and fundamental questions: How do we measure our place in the universe?

1 Ingrid Schaffner, "Lilla LoCurto and William Outcault," *Artforum* (November 1994), p. 86.

2. Bruce Guenther, *New California Art: LoCurto/Outcault* (Newport Beach, Calif.: Newport Harbor Art Museum, 1993). I am grateful to Bruce Guenther for his comments on *Self Portrait*, 1992.

3. In conversation with the artists, July 6, 1999.

4. The artists wish to thank Daan Strebe, Dr. Helaman Ferguson and Dr. Samuel Ferguson for their creative input.

5. *selfportrait.map*, Lilla LoCurto and William Outcault, written statement, 1998.

6. Ibid.

7. In conversation with the artists, July 2, 1999.

The
Self Made Map

David Gelernter

LoCurto and Outcault's *selfportrait.map* is based on a simple idea that requires a sophisticated, technology-intensive realization. It's an elegantly straightforward idea that seems obvious in retrospect, as the best ideas always do; but its implications are rich and subtle. The method is novel—but yields images that arouse answering echoes all over the art-historical landscape. The "self-portrait" that results is idiosyncratic and original — and constitutes a compelling answer to the No. 1 question on today's artistic agenda: How do we depict human beings here in the Post-Everything Age?

After all, human beings are mainly interested in human beings — in themselves and one another. An artist can paint (or write about) trees or zebras or still-lifes, buildings, oceans, mountains, machines. But the masterpieces that move us most are likeliest by far to be about human beings — to the extent they are about anything.

In the 20th century, art drove full-speed (and on purpose) into a brick wall. It was a dazzling crash, and we gained some spectacular masterpieces in the process. But we lost something, too. Our techniques for making nudes and portraits had evolved steadily for millennia; in the Great 20th-Century Crack Up, we lost the thread. Progress on nudes and portraits almost stopped (a great river became a neurotic threadbare trickle): we excused ourselves to get a cup of coffee and make some gorgeously self-indulgent abstract paintings.

Abstract expressionism turned into a color-drunk romp, and art has been hung over for thirty years in its aftermath. It's time to get over it and move onward. Today's most interesting artists are picking up the thread. The art of the human being is once again moving forward.

Here is the same proposition from a slightly different angle (in the spirit of LoCurto and Outcault, who repeatedly approach the same subject — themselves — from different angles, with fascinating results). Two of the three greatest 19th century painters had obvious 20th-century successors and hugely affected, through these successors, the art of modern times. The third member of the great 19th-century troika had no obvious successor. The story of his art ends with an abrupt 'To Be Continued,' and we are still waiting to see how it all turns out. The two 19th-century masters with 20th-century consequences are Cézanne and van Gogh, Cezanne pointing to cubism and onward (by way of Duchamp) to every sort of mind-art, van Gogh to Fauvism and Matisse; the two of them jointly to abstract art. But then there is Degas, who actually lived well into the 20th century and who is, arguably, the greatest of the three. And he has no real 20th-century disciples. It's no coincidence that Degas's art is the art of the human body; we still don't know where it leads.

"Where does Degas lead?" is a hard question because we do know that the way forward is not photo-realism or neo-realism or any kind of realism. Degas showed us how to transcend realism, and we can no longer settle for anything less than the superb expressive intensity of his trans-realistic nudes — especially the late pastels, which in terms of sheer power are practically thermonuclear. We need to move forward from there. How? The best hints are in Modigliani and Giacometti, two sculptor-painters who weren't quite Degas disciples but came closer than anyone else. In different ways they each used the human body (as Degas had done, and for that

17

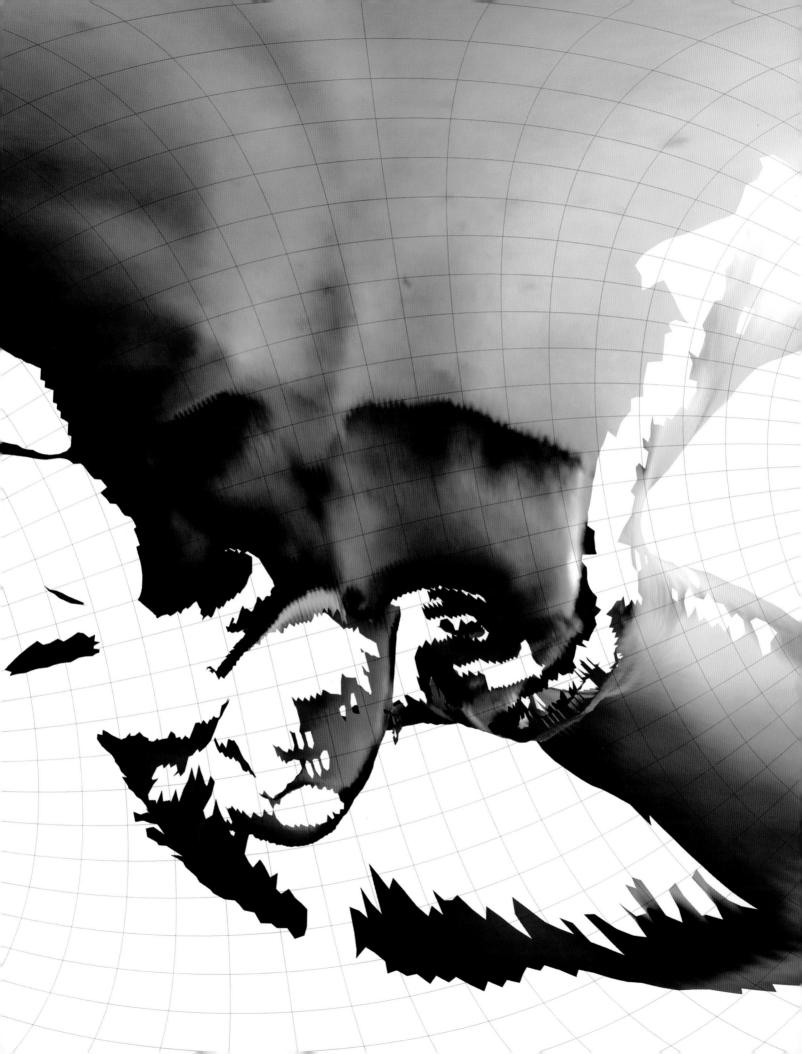

matter Michelangelo) as a language for vividly beautiful, gripping images. Their nudes and portraits aren't realistic in any conventional sense.

But they both happen to speak "human body" fluently, and their deep knowledge of drawing and anatomy underlies everything they do. Their pieces succeed because they preserve the body's basic structure and texture while transcending the details of its literal appearance. Where "human body" is spoken well, we can't help but respond emotionally. Which brings us to *selfportrait.map.* How to preserve the body's basic texture and architecture without succumbing to mere Freudian neo-realism is a hard question. LoCurto and Outcault have arrived at a fascinating, persuasive answer.

In *selfportrait.map*, images of the human body are flattened and transformed as the earth's image is flattened and transformed when we make a map. Of course no 3-D body can be wholly and accurately reproduced in a 2-D image; every scheme for projecting three dimensions onto two is a compromise, relatively truer to the original in some ways and more distorted in others. *selfportrait.map* uses a series of different projections, and the results are novel and haunting. The premise itself is novel and haunting: we are used to thinking of (and depicting) the human body as a three dimensional object, but LoCurto and Outcault treat it as a surface − an undulating, convex surface, wrapped (like a tennis ball or an empty taco shell) around a provocative void.

Ordinarily we depict the human body as a solid object, seen whole from a single vantage point; we depict the earth as a surface, with an implied moving vantage point that takes in everything − in accordance with our everyday, human-scale experience. We can see a nude (but ordinarily, not the whole earth) at a glance. And so the type of picture we call a "nude" shows only part of the nude; the type we call a "world map" shows an entire surface. But in principle (say LoCurto and Outcault), it could just as well be the other way around. Their shift of viewpoint says, in effect: Suppose we treat the human body (or a pair of humans) as a world in itself? This change in perspective is disorienting and therefore eye-opening. But despite their newness, these pictures are rich in art-historical resonance also. The artists themselves refer to the "element of abstracted violence" in their pictures, which show the human body "as a hide or skin to be displayed on the wall." The canonical masterpiece that comes closest to LoCurto and Outcault's *selfportrait.map* is the strangest, most disturbing self-portrait of all: Michelangelo's, of himself as the flayed skin of Saint Bartholomew, hanging lifeless near the center of the Last Judgement. Don't look at LoCurto and Outcault's pictures unless you are prepared to be disturbed. In a sense they are doing, when they show us a whole nude at once, what the Cubists already did; but Cubist paintings have none of these provocative associations.

The idea of a "world map" implies both a physical and an intellectual frame of reference. Some of these images have grid lines that show the contours of the projection, like a world map's latitude and longitude lines. The grid creates a rhythmic bass that makes the images easier to read and gives them an uneasy coherence − as if these shapes are about to fly apart and are only just held together by a delicate framework (the analytic attempting to restrain the sensual; good luck!). In some cases the distortions are especially weird and unsettling, and the grid

Equidistant Cassini
B1Osph(1/1)2_98 (plate 13)
(detail)

lines escort us (for example in *Equidistant Cassini B10sph(1/1)2_98*) (plate 13) across heaving, forbidding territories and dangerous voids.

The intellectual framework says: You want to discover something? Discover this. Want to map something? Want to know where today's unknown territory (beyond the frontier) really lies? After a spectacular epoch of exploration and technological advance, we are back where we started: trying to figure out humanness; desperate (in every sense) to get a grip on the human body. So the "world map" is a fruitful idea. But the most striking aspect of these images is their beauty and their spiritual content. Several of them stop you in your tracks. *Bipolar Oblique BS1sph(8/6)7_98* (plate 5), for example: two hands grasped; two fetal feet; a soaring face presiding with a strange, other-worldly expression. The strong horizontal of joined hands brings up Michelangelo again, God awakening Adam. But in LoCurto and Outcault's version we get, instead of the languid grace of a divine touch, one hand holding the other by the wrist — as if God were reluctant to let go, and were maybe having second thoughts. Except that both hands belong to the same person: man creating himself? *Kharchenko-Shabanova BS1sph(8/6)7_98* (plate 9) uses the same themes and is even more powerful — hands clasped across a great rocking, heaving rhythmic swell.

Stereographic L6sph(8/5)7_98 (plate 10) is monumental: a white square with a circular image inside — the female body as a perfect, womb-centered circle. The shape and strength of the piece suggest a gothic rose window, but I can't help imagining this image on the concave interior of a soaring renaissance dome. It has the sensual intensity of Correggio at his best. In *Polyconic BS1sph(8/6)7_98* (plate 7) you get the disturbing impression of looking right into the center of a human being; it's a picture of the space inside a man. In *Adam's World in a Square I L3sph(8/6)7_98* (plate 18), the presiding face is the face of a broken doll that has come alive, or gone to heaven, or somehow been transfigured. The faces in *Mercator BL1sph(8/8)7_96* (plate 6) know something that we don't know, and they aren't telling. (Maybe it can't be put in words.) Few faces in the history of art are as haunting and disturbing as the faces LoCurto and Outcault achieve here.

Occasionally, a spectral fringe of (faintly greenish) blue emerges, exactly right to bring out the warmth and depth of the predominant colors, rich rusty browns, pale buff through burnt umber. The occasional blue fringe is wholly welcome and unexpected.

The scientists and technologists (particularly Samuel Ferguson) who helped LoCurto and Outcault invent and apply their mapping methods were obviously important to this project. Still, their contributions ought to be understood in the right way — as roughly analogous (it seems to me) to the contributions of the industrial chemists who invented the acrylic binders and synthetic pigments so many artists have relied on for decades. Technologists create tools, not art (except when a miracle happens — and miracles happen rarely). Which isn't to downplay the importance of technologists who are smart and wise enough to invent new tools for artists. Art history is a counterpoint for two voices. Artists who want to go farther than contemporary tools permit (who need fresh techniques to support fresh visions) ask technologists for help. Technologists deliver the goods and then some — they nudge art forward, and help lay the basis for

Mercator BL1sph(8/8)7_98
(plate 6)
(detail)

20

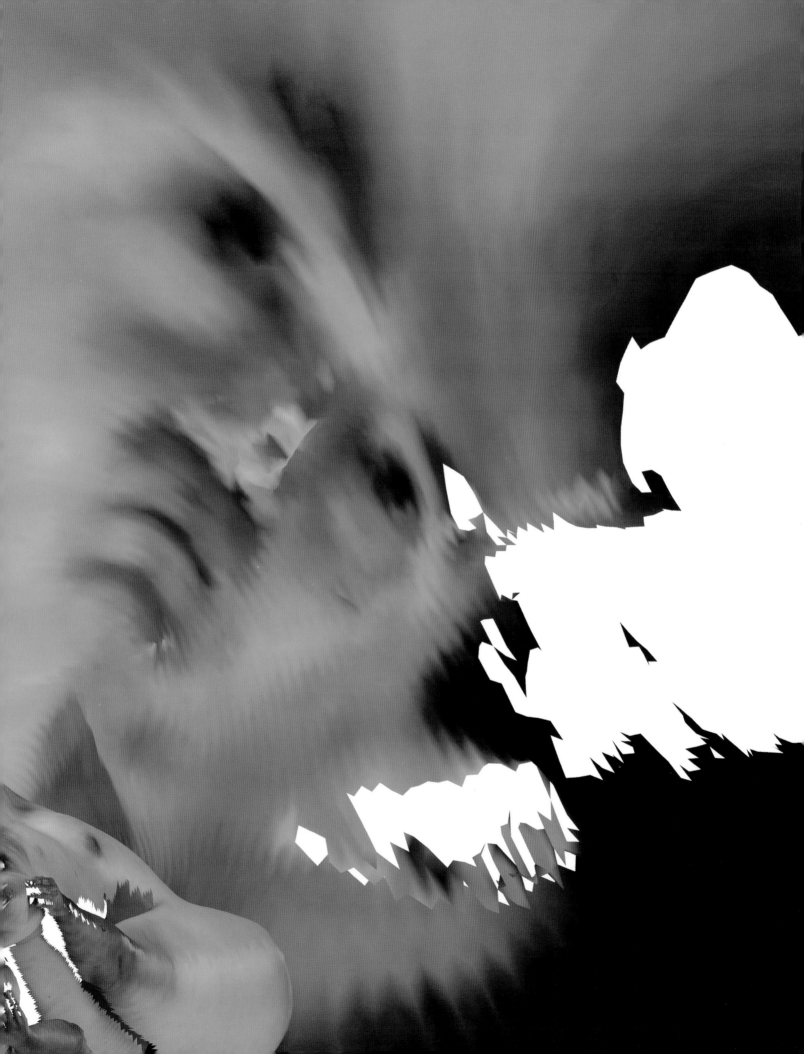

new visions and further requests. This high-energy interplay between art and technology is typical of 20th-century intellectual life at its best. And *selfportrait.map* is the work of artists who are grateful to technologists for giving them fine, powerful tools. But if these particular tools had never existed, the artists would have shrugged their shoulders and used other tools — and the finished product would have been different, but maybe less different than we tend to suspect.

What counts in the end, of course, is not how these pictures were made but how deep, beautiful and surprising they are. LoCurto and Outcault have assembled one of the best answers we've seen in a long time to the question so many artists are struggling with (I struggle with it myself every day in my own paintings): How do we pick up the thread? How do we make successful new images of the human body? *selfportrait.map* is a deep answer to a deep question — and it is a memorable, superbly evocative bunch of pictures.

selfportrait.map

All works are from 1999, chromogenic prints mounted on aluminum

B.S.A.M. BL1sph(8/7)7_98
48" x 69½"

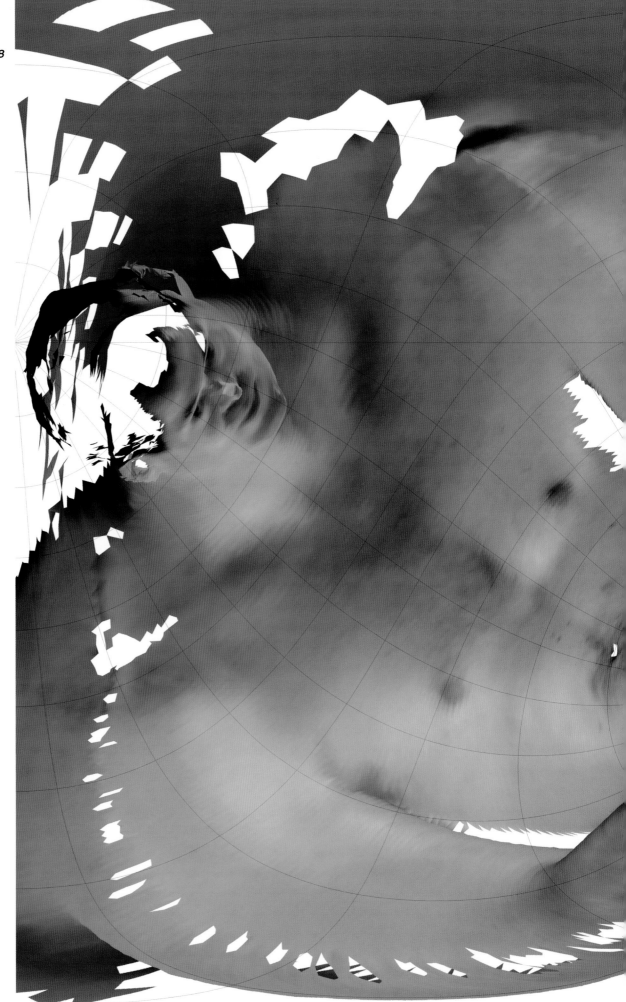

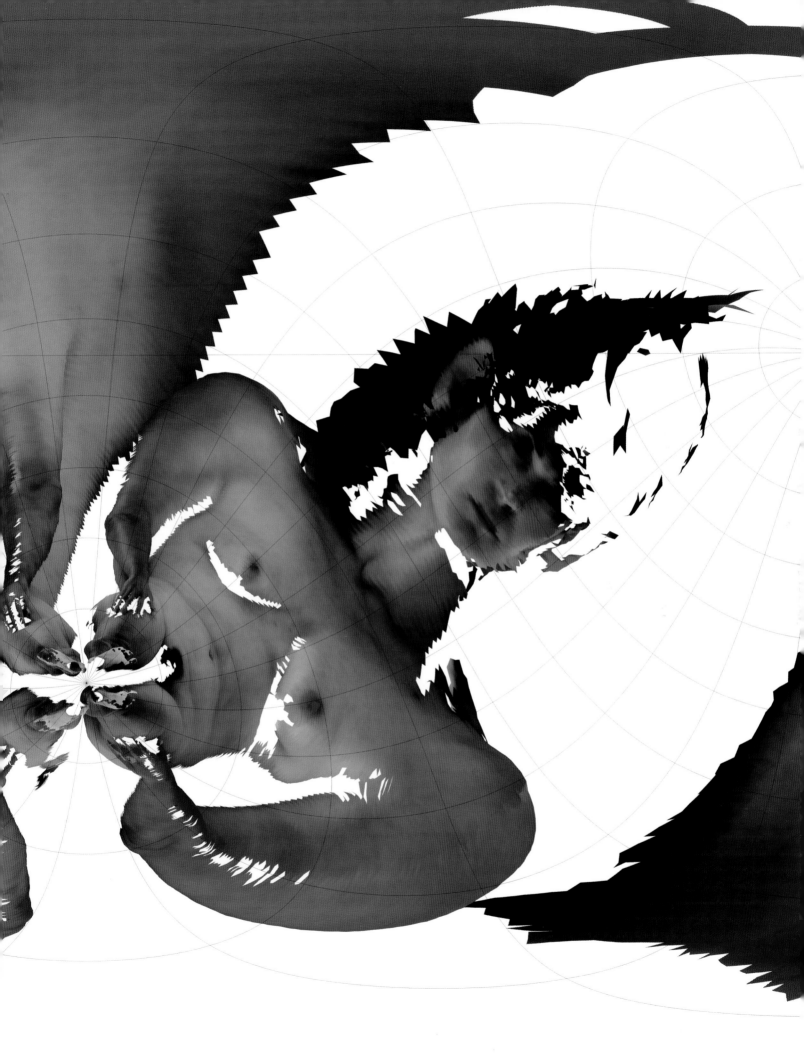

2
Urmayev III BL1sph(8/5)7_98
48" x 52"

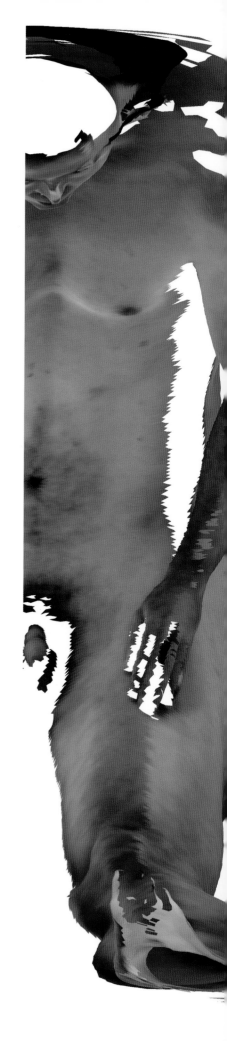

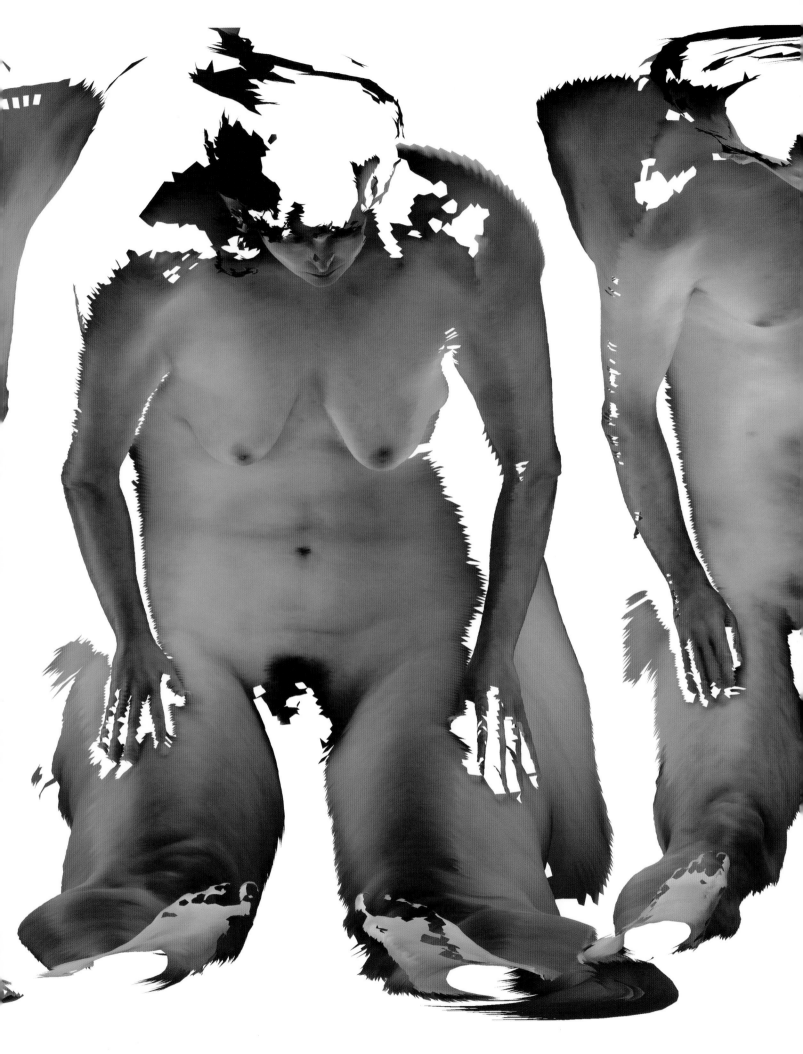

3
Conformal Eisenlohr BL1sph(8/8)7_98
48" x 74½"

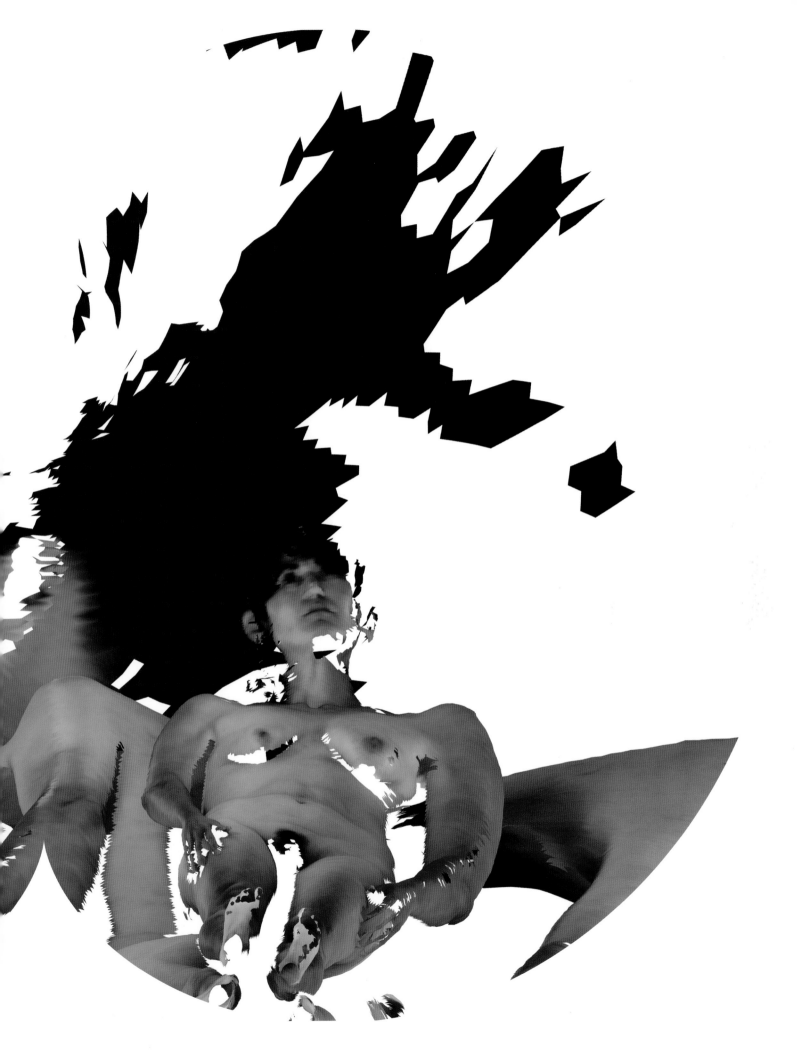

B.S.A.M. BC2sph(8/6)7_98
48" x 70"

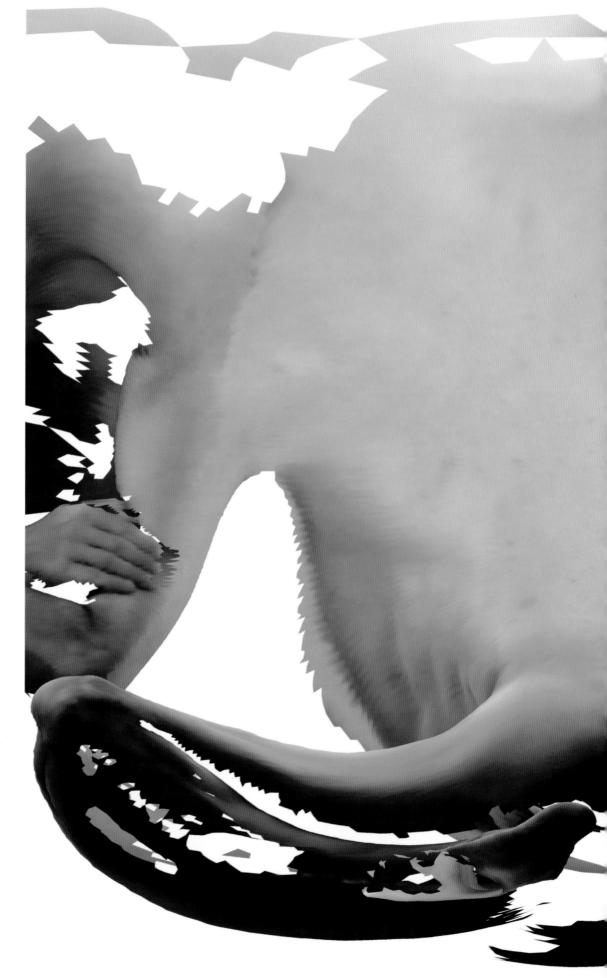

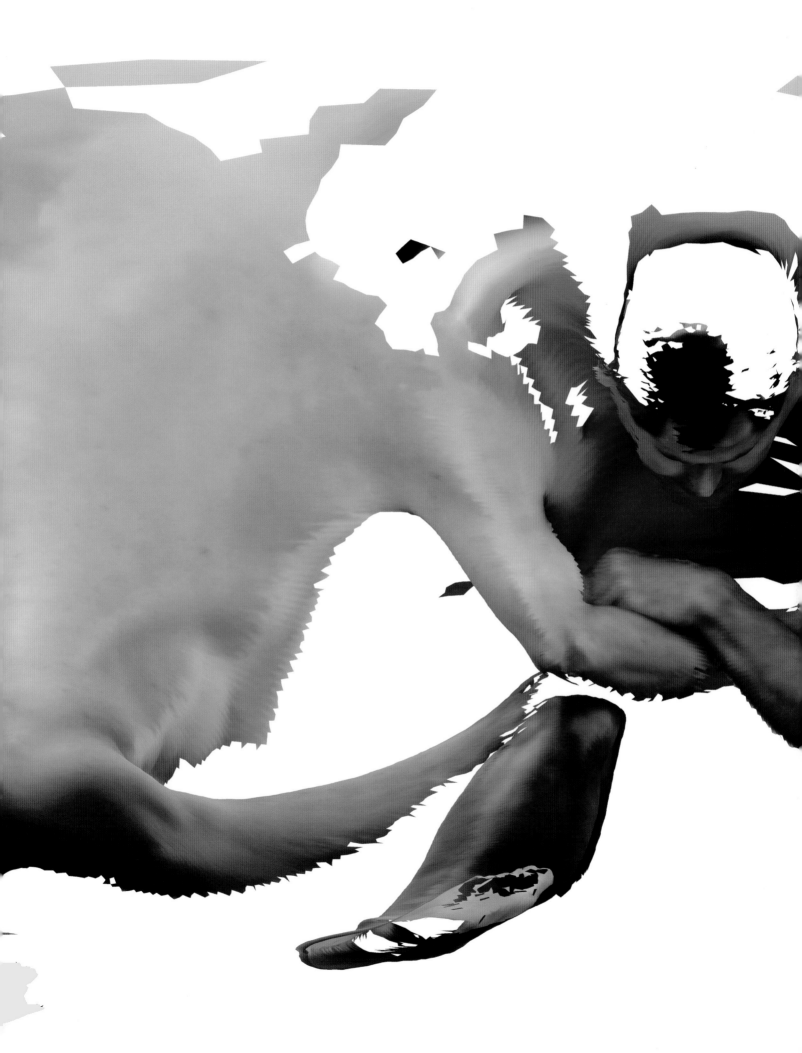

5
Bipolar Oblique BS1sph(8/6)7_98
24" x 24"

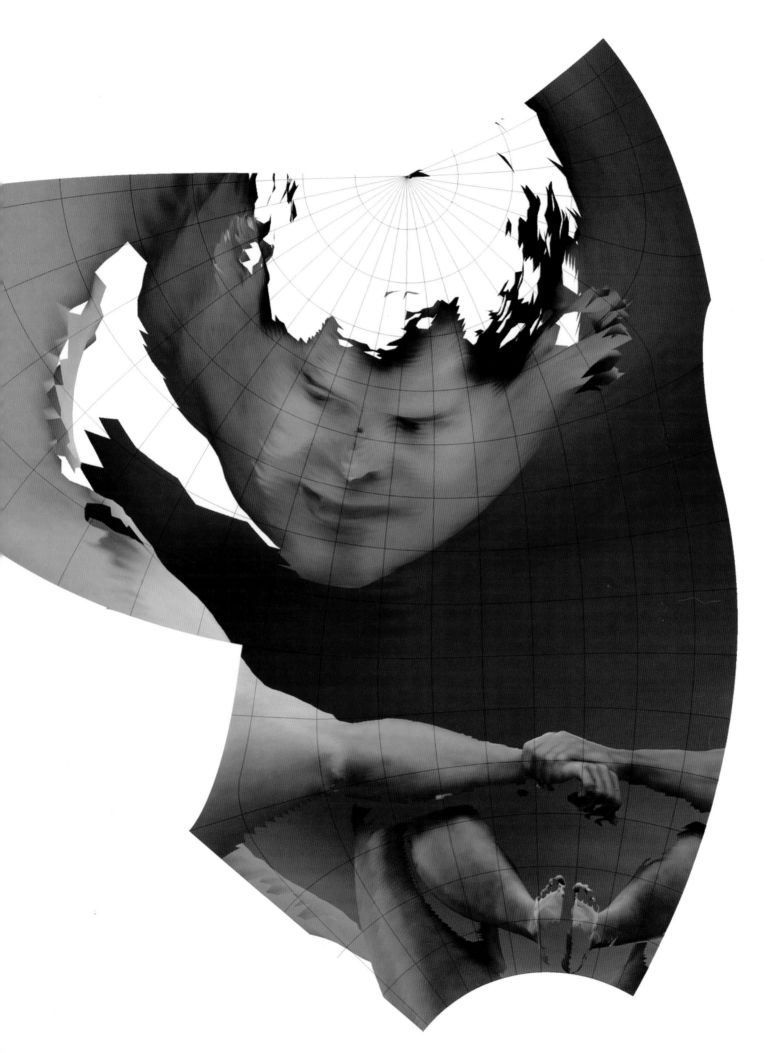

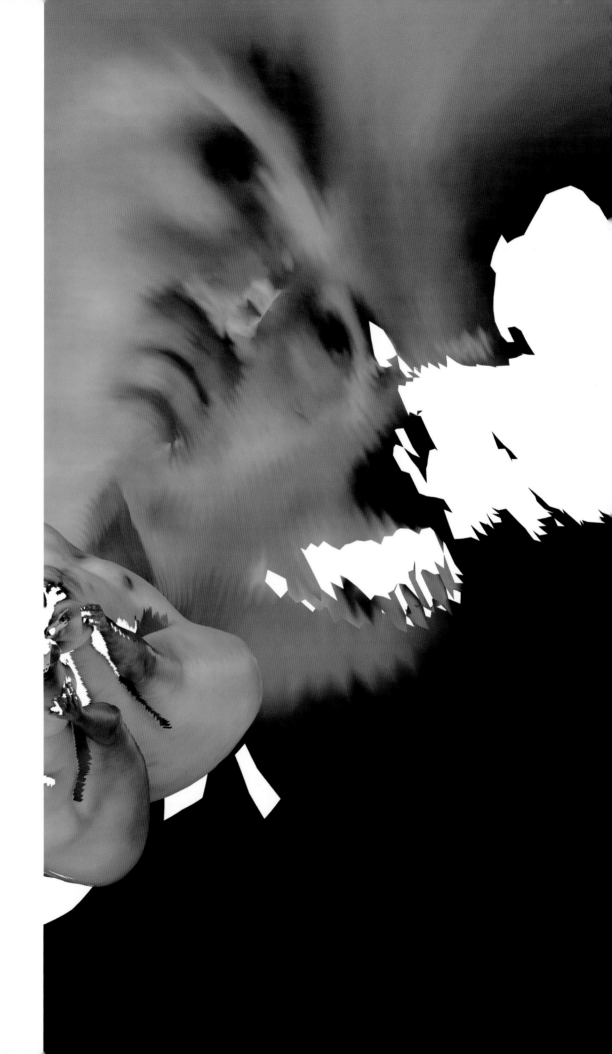

6
Mercator BL1sph(8/8)7_98
48 x 59"

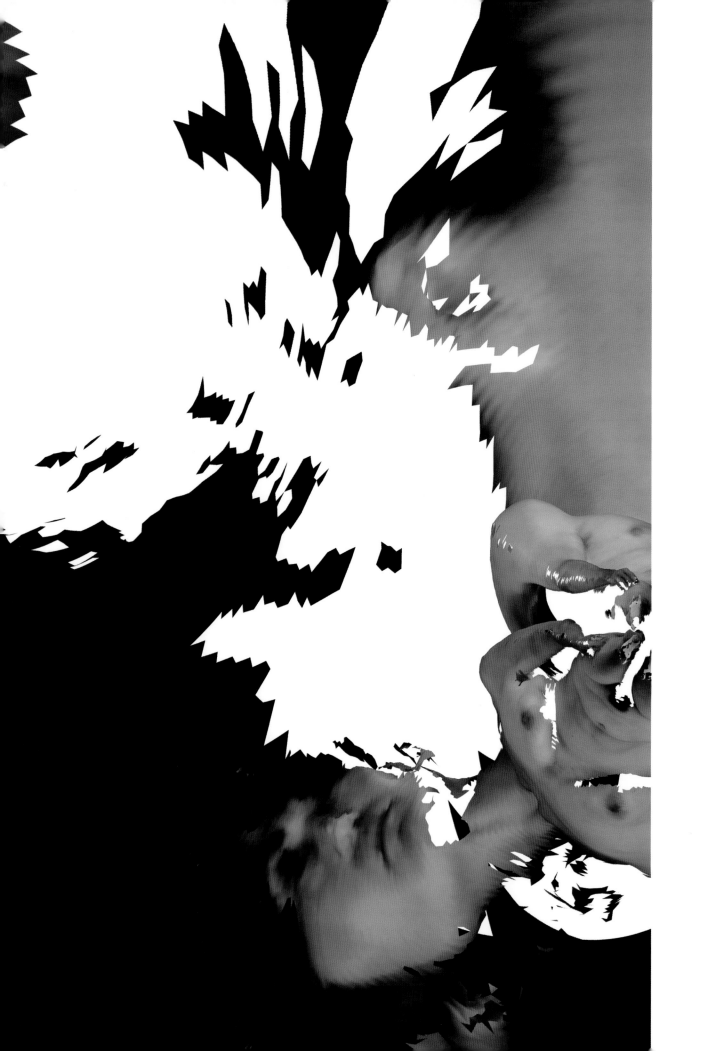

Polyconic BS1sph(8/6)7_98
48" x 62½"

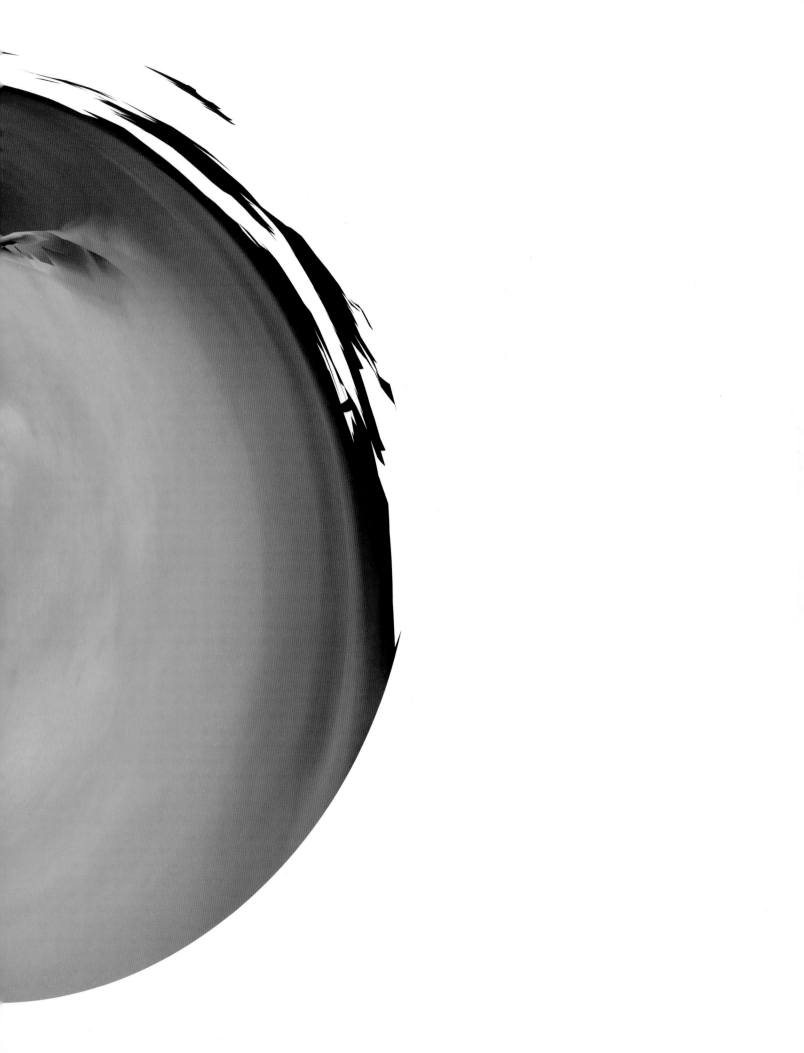

Gall Stereographic L8sph(8/8)7_98
48" x 62½"

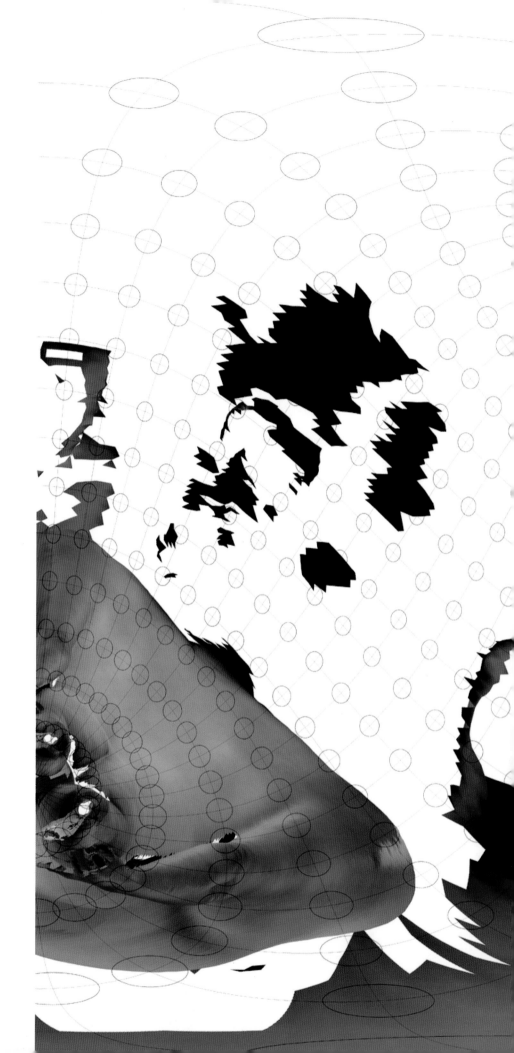

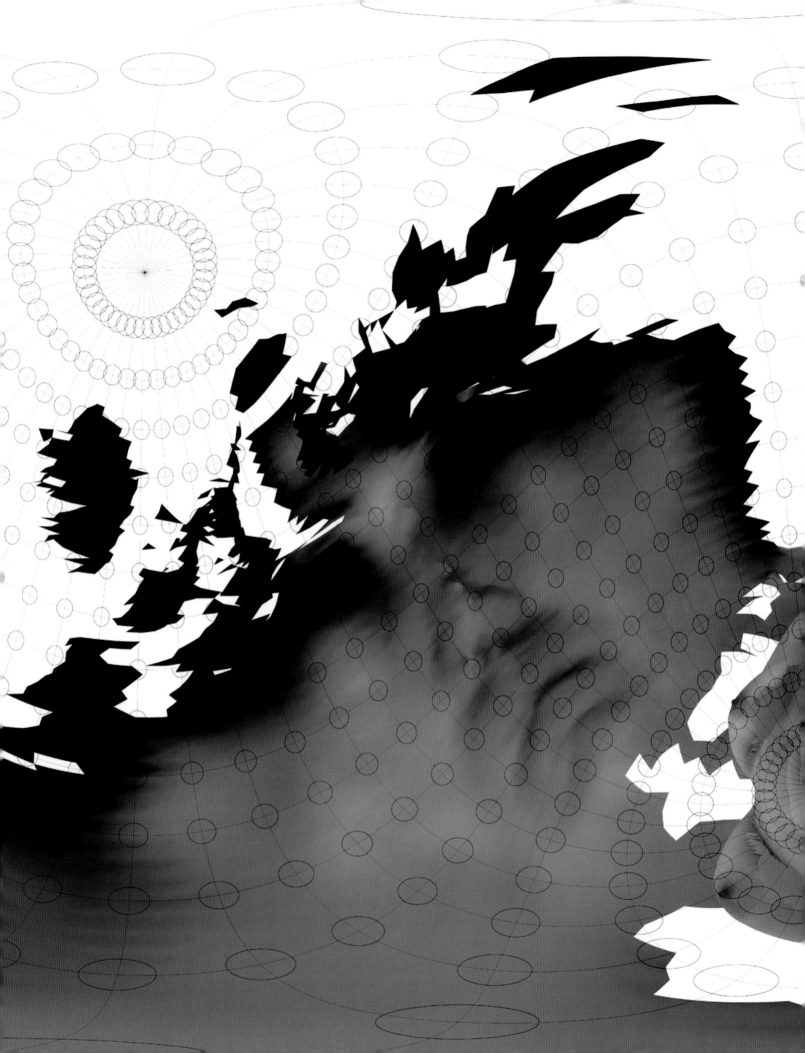

9
Kharchenko-Shabanova BS1sph(8/6)7_98
48" x 57½"

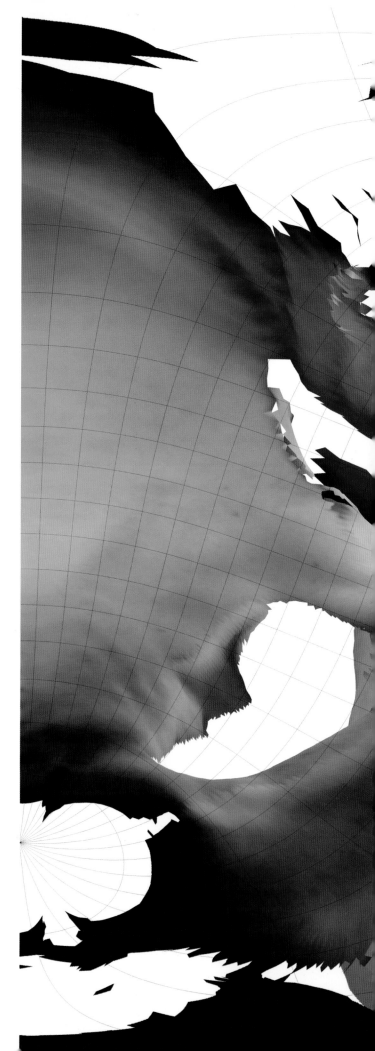

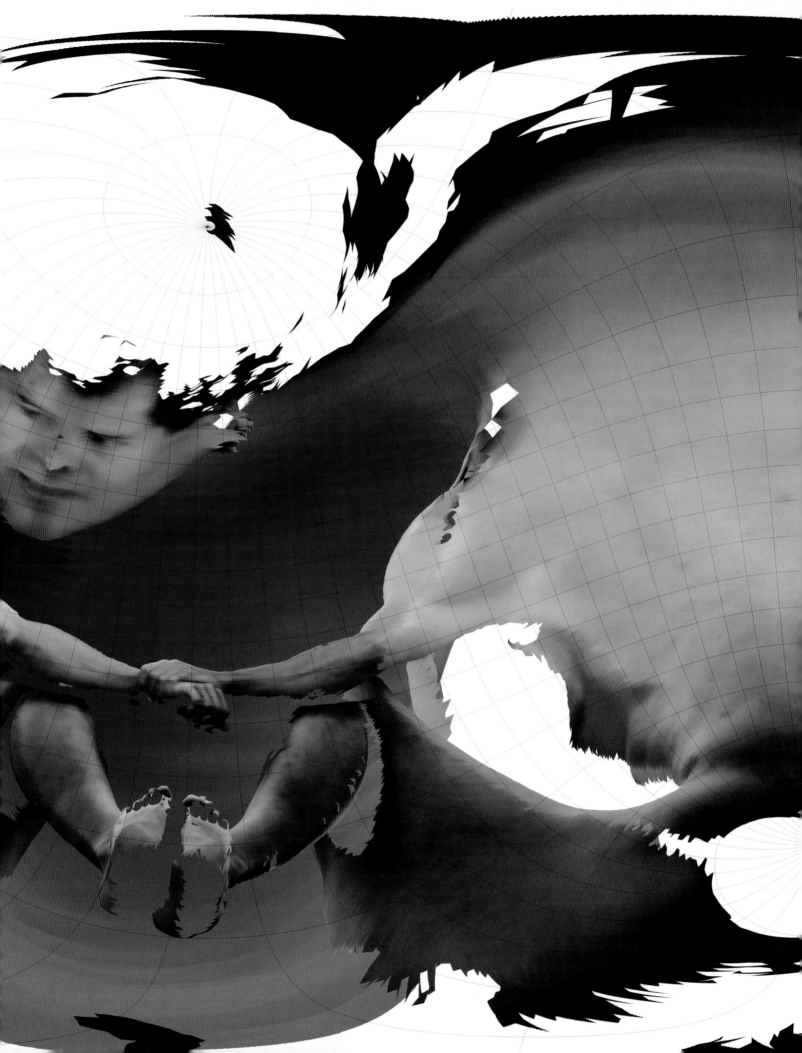

10
Stereographic L6sph(8/5)7_98
24" x 24"

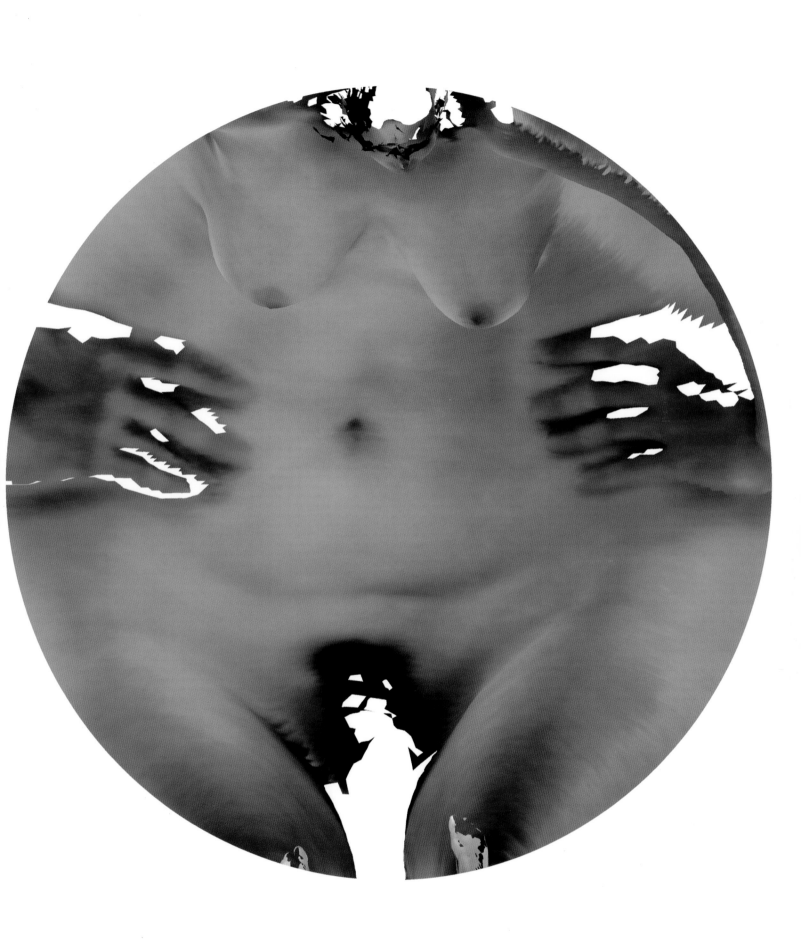

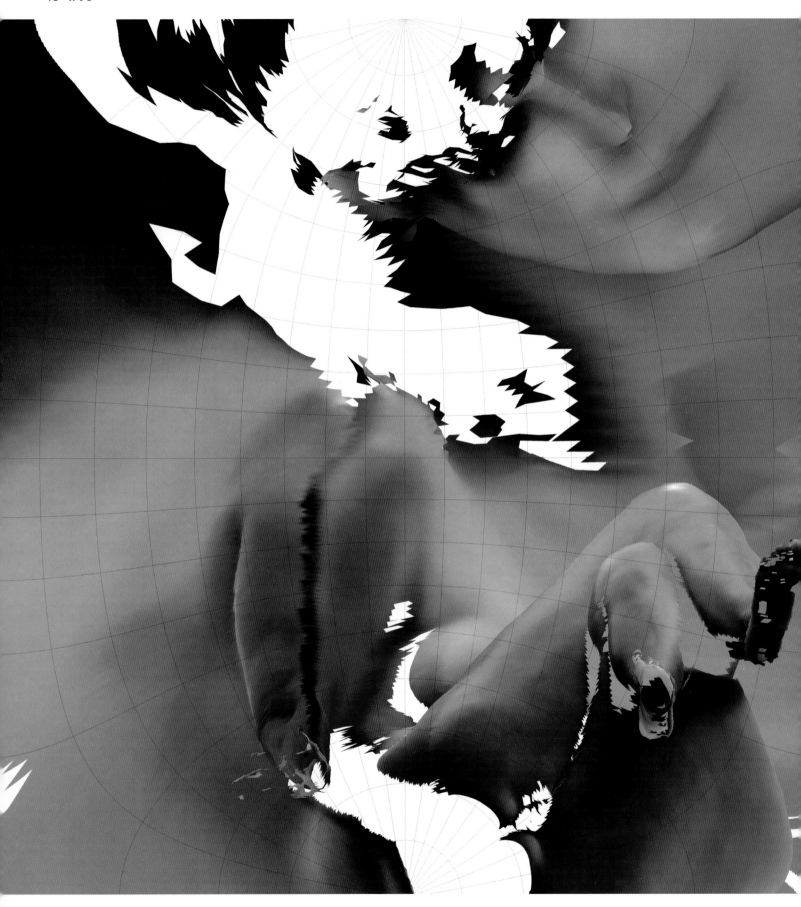

11
Conformal Guyou L2sph(8/6)7_98
48" x 96"

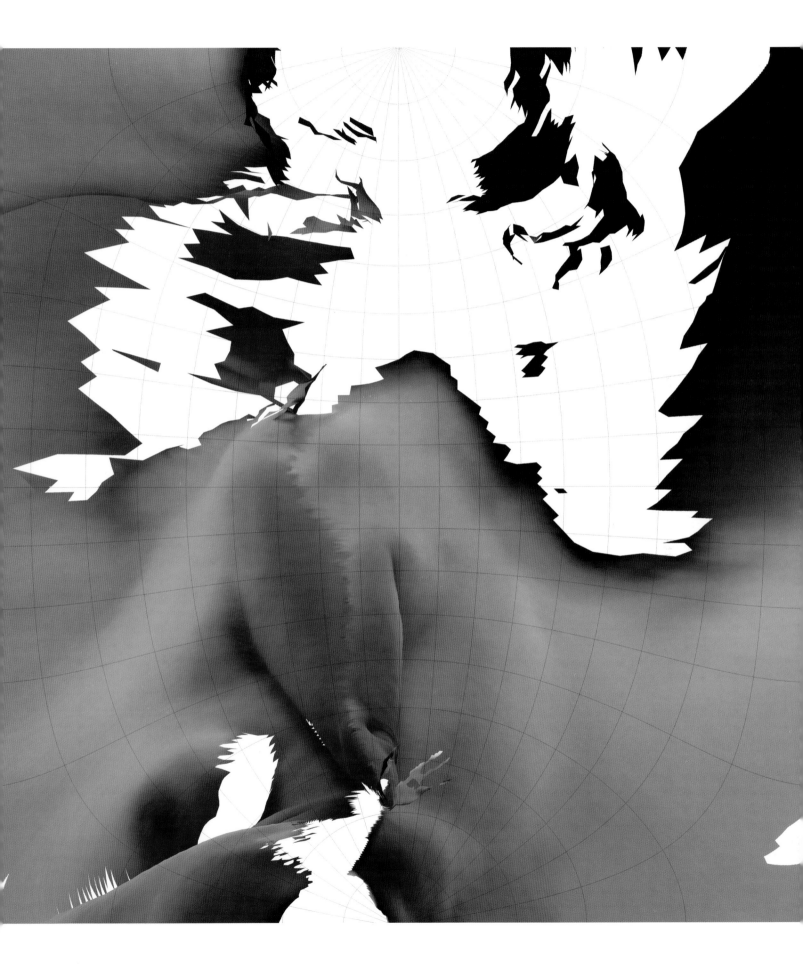

12
Urmayev III L6sph(8/6)7_98
48" x 52"

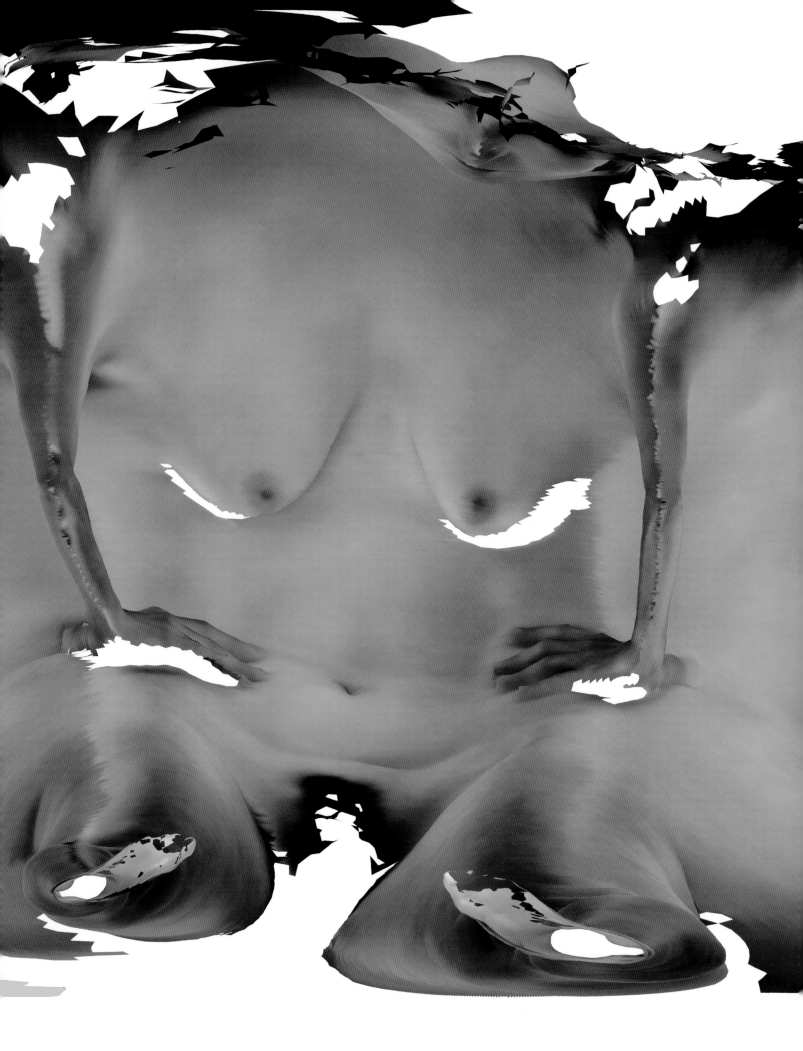

Equidistant Cassini B10sph(1/1)2_98
48" x 96"

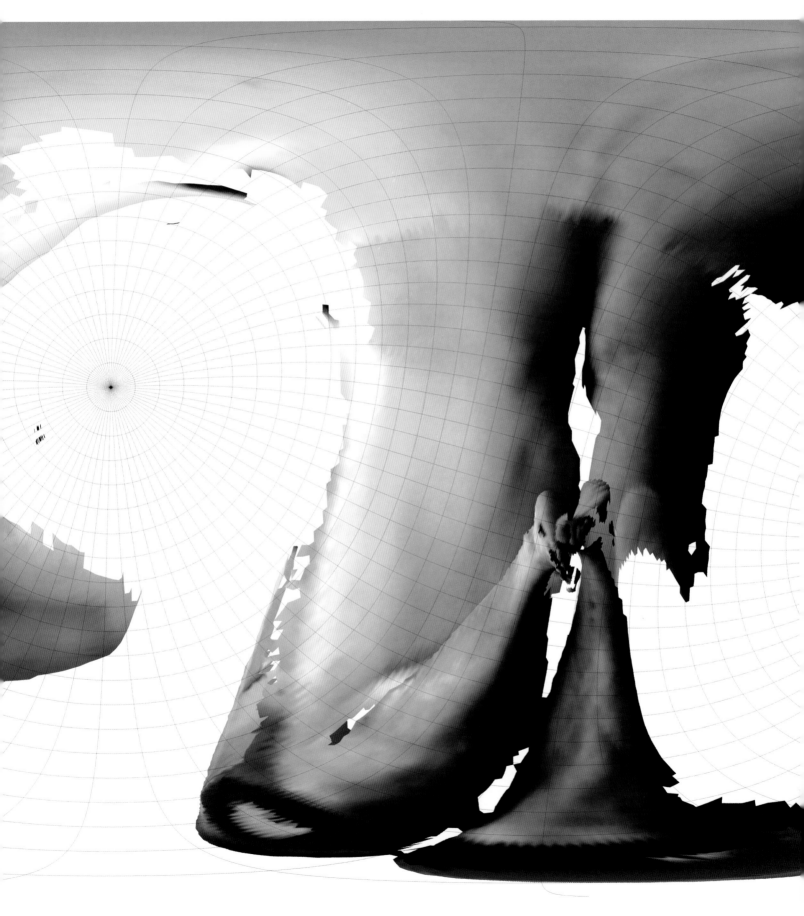

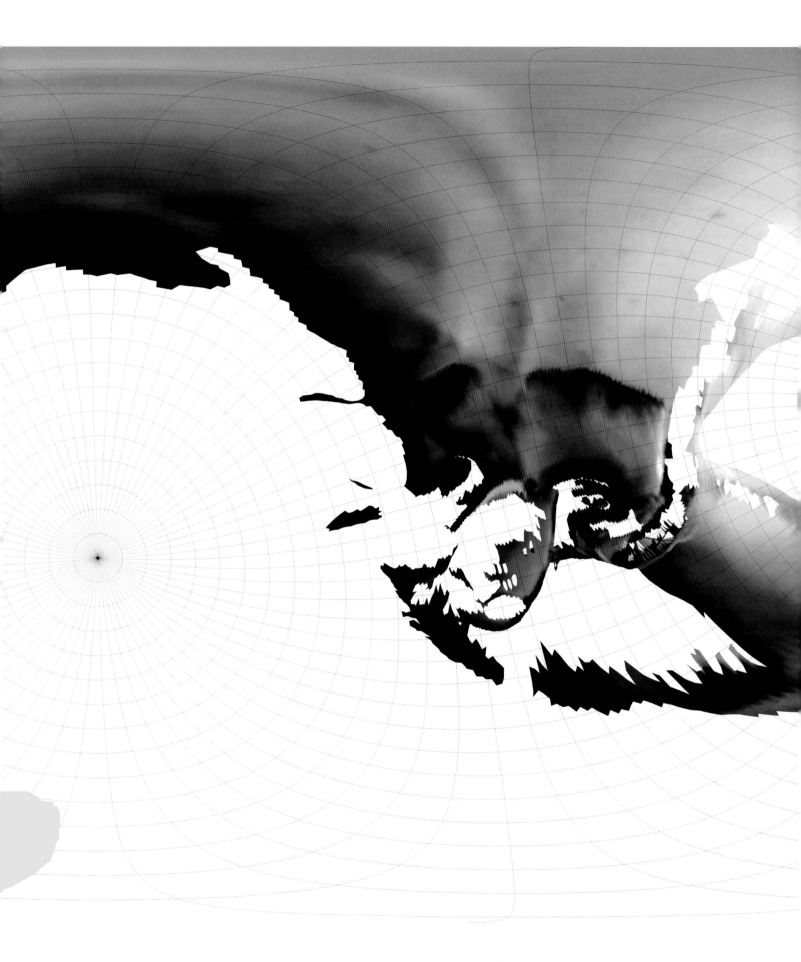

Apianus II BL3cyl 7_98
48" x 96"

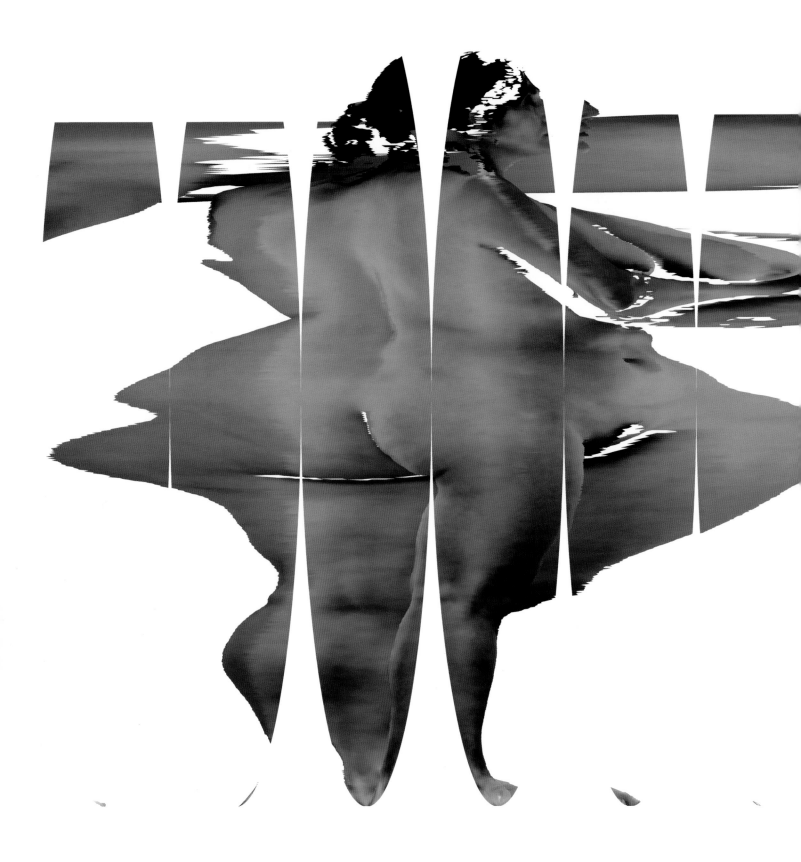

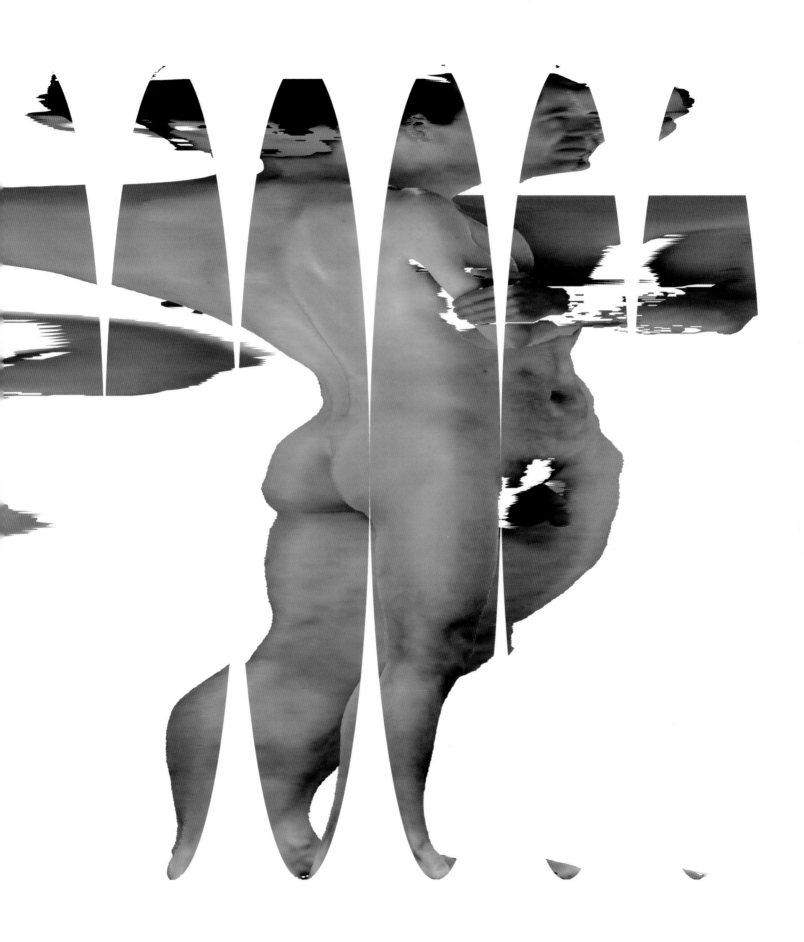

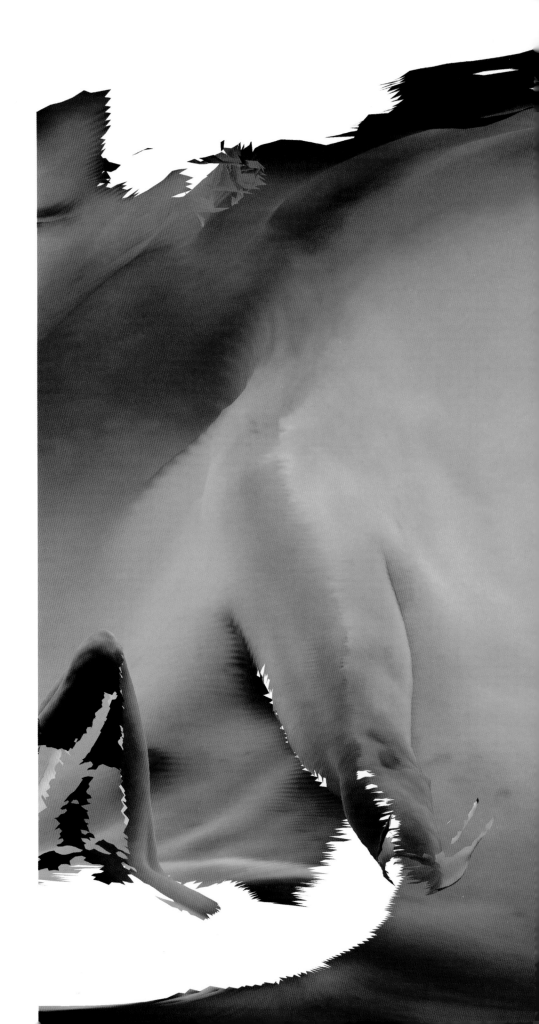

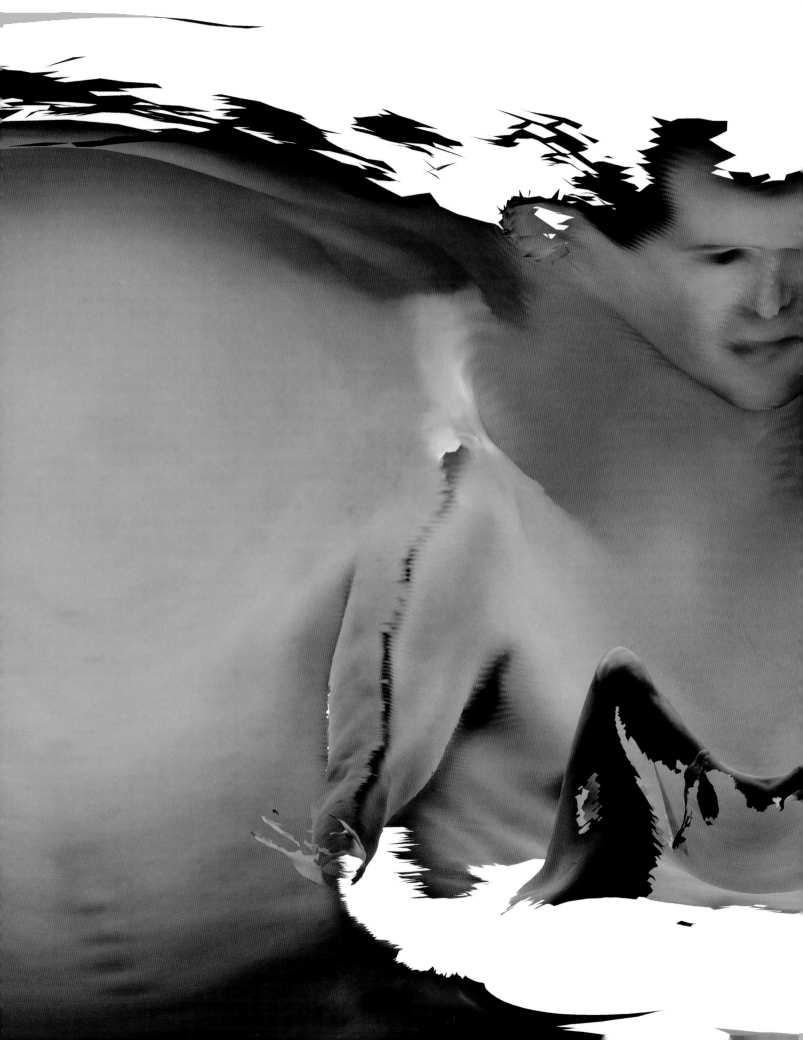

Urmayev III B3sph(8/8)11_97
48" x 52"

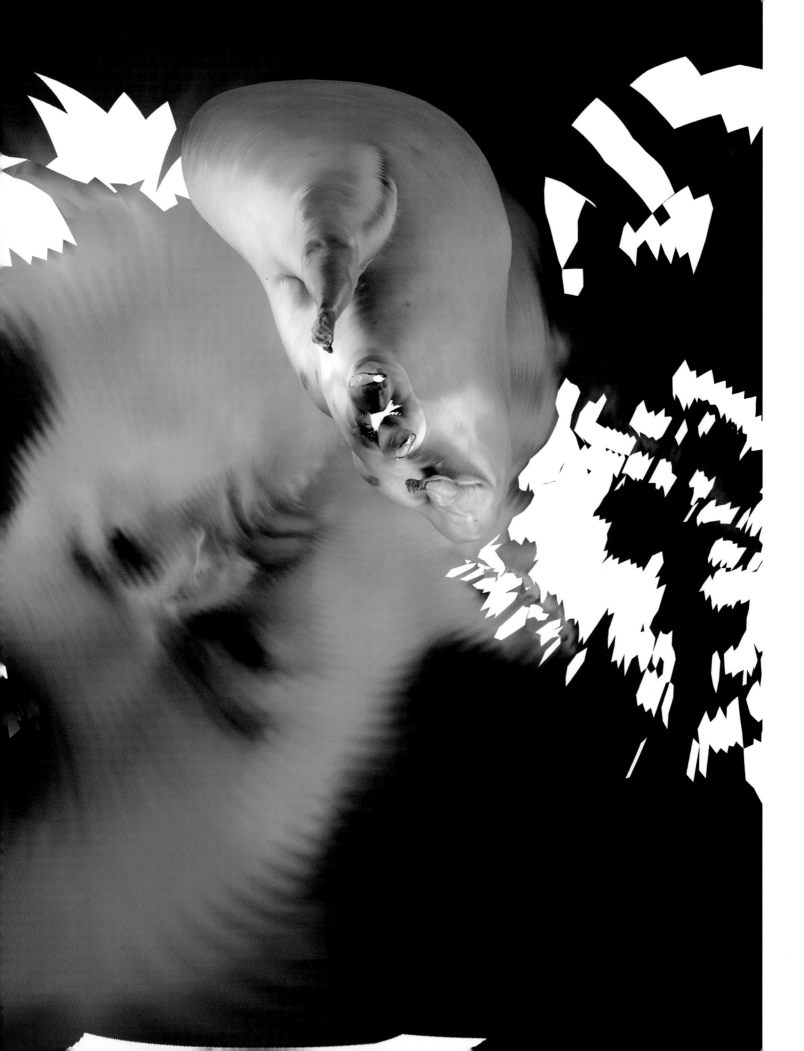

17
Urmayev III L3sph(8/6)7_98
48" x 52"

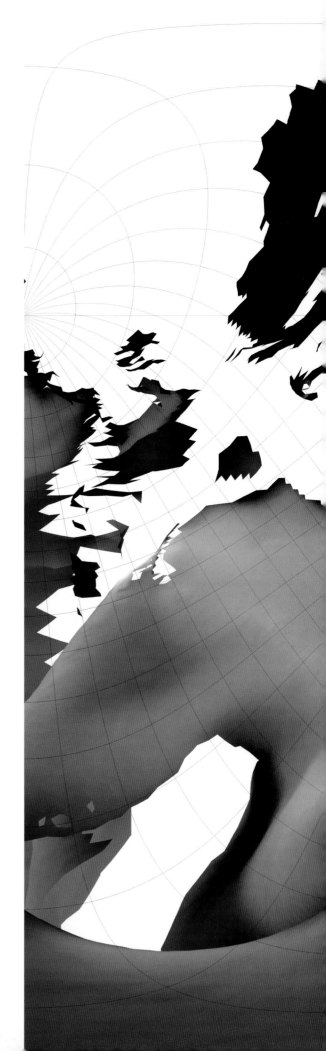

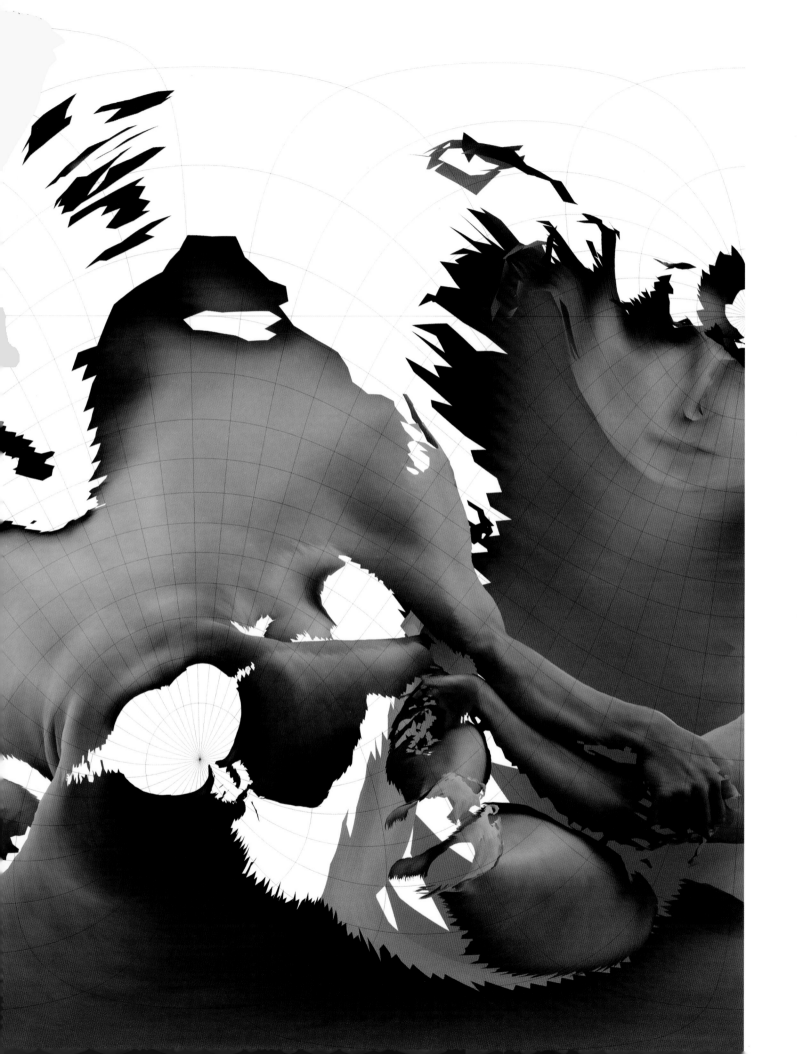

18
Adams World in a Square I L3sph(8/6)7_98
48″ x 48″

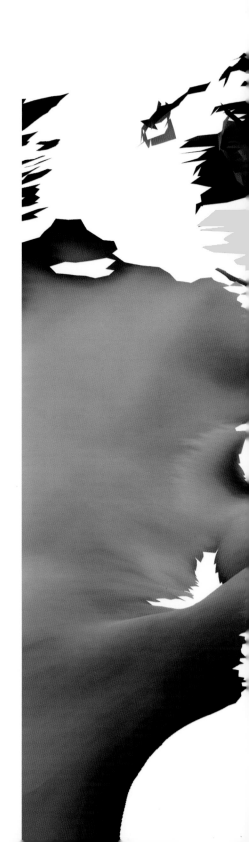

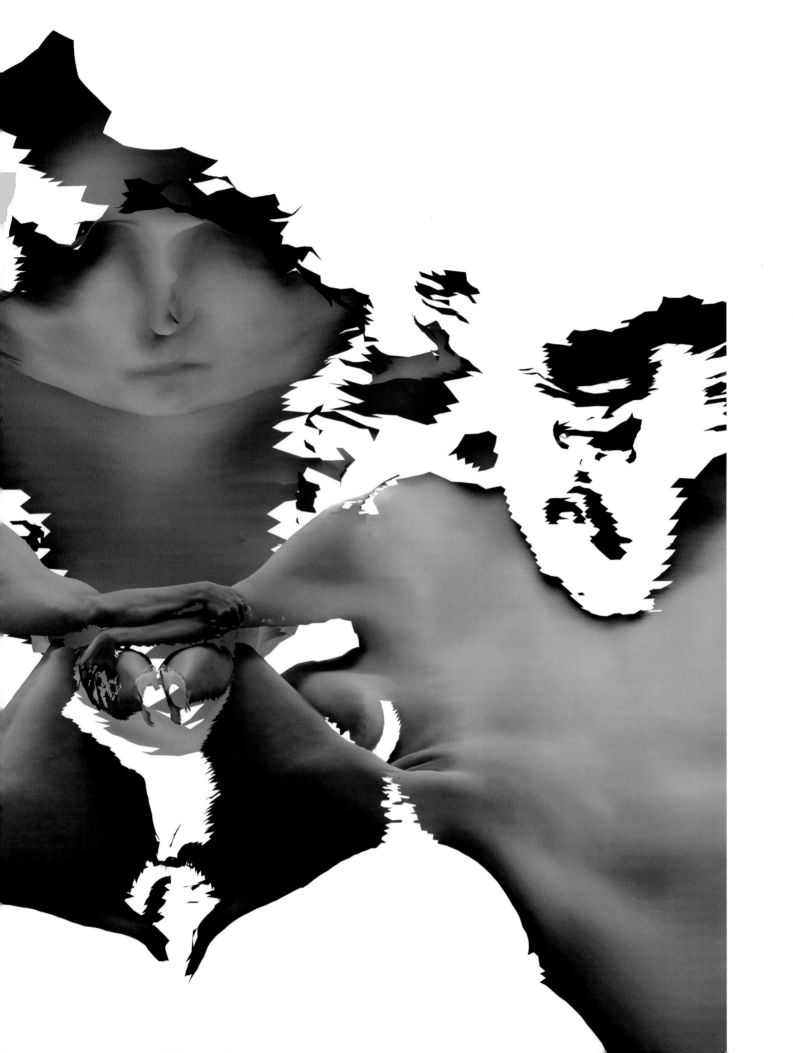

Chronology

1976-1978 Bill Outcault and Lilla LoCurto meet at Southern Illinois University where both receive MFAs in sculpture in 1978.

1979 Both artists teach at Indiana State University, Evansville; awarded an Indiana Arts Commission Grant for a collaborative project, *Forms that Float*.

1980 Move to Los Angeles; work independently until 1991.

1992 First collaboration since 1979: *Self Portrait*, an interactive installation. Outside experts are consulted, including Mike Mariant, a design engineer, and Julian Nikolchev, a biomedical engineer, establishing a working model that will shape future collaborations. The project receives funding from Art Matters Inc. and MIT as well as technical support and materials from a number of corporations. Installation is exhibited in *Corporal Politics* at the MIT List Visual Arts Center, curated by Helaine Posner.

1993 The Orange County Museum of Art in Newport Harbor, California (then known as the Newport Harbor Art Museum) exhibits *Self Portrait* (1992) as part of the "New California Art" series. Later that year, an installation titled *Self Portrait: Stained Glass*, made from transparent still images derived from *Self Portrait,* is exhibited at the Armory Center for the Arts in Pasadena, California.

1994 A new interactive work, *ABC*, is commissioned by the Los Angeles Municipal Art Gallery for a show titled *About Place, LAX: The Los Angeles Exhibition*. Three monitors and cameras with audio place the viewer in what appears to be a two-way conversation occurring between three people. The ensuing dialog was constantly edited, rotating the dialog between the three people and filtered by the unseen third party.

During a residency at Harvard University's Carpenter Center, LoCurto/Outcault create two installations. The first, *Mandala*, employs automobile airbags in contemplation of an instant of impending disaster as eight airbags, arranged along a wall, inflate randomly and explosively. Juxtaposed with this violence is the airbag in its resting state which forms a contemplative minimalist object or a Zen mandala. The second work, *Sharp Appetites,* is a commentary on our society's affair with enhanced human beauty. Several plastic surgeons are consulted for this project. Silicone breast implants are not only a component of the work but also a graphic metaphor for the way aesthetics are culturally perceived.

First solo show, *Titillatiae*, at TZ'Art & Co. in New York City includes elements of *Sharp Appetites* and other works expanding on this theme.

1995 *Self Portrait* (1992) travels to the John Michael Kohler Art Center in Sheboygan, Wisconsin for an exhibition titled *Face Forward: Contemporary Self Portraiture*.

Second solo exhibition at TZ'Art & Co. titled *Skin Deep*, an examination of the cultural perceptions and biases of gender. Two group shows follow, one at the University of North Texas, *Gender Myth and Exploration* and *A Vital Matrix* at a gallery, domestic setting, in Los Angeles.

1996 Travel to England for a group exhibition, *Contemporaneou.s.* in Newlyn, Penzance that travels to Sunderland.

Begin research on *selfportrait.map,* an abstract inquiry into mapping the human figure as a flat plane. A flatbed scanner is used to approximate simple projections created from a collage of individual body parts. The artists locate a three-dimensional scanner at the U.S. Army Natick Soldier's System Command. This technology advances the project.

1997 *Self Portrait* (1992) travels to Barcelona, Spain as a solo exhibition titled *Cossos Exquisits* at the Fundació Joan Miró. Technical support is sought from MIT to continue research on *selfportrait.map* and a grant is awarded by the Council for the Arts at MIT. Additional grant support is received from the Lyman Allyn Museum of Art at Connecticut College in New London, Connecticut. Several cartographers suggest they work with physicists due to the mathematical complexities of the project. The artists meet Daan Strebe, a computer scientist and the author of "Geocart," a cartography software with the ability to import various databases. Strebe recommends Dr. Helaman Ferguson, a mathematician and sculptor, based on his expertise in complex volumes and topographies. Dr. Sam Ferguson, Helaman's son, expresses interest in the project and devotes months to developing a software, making the scanner data fit into *Geocart.*

1998–1999 Muse [x], a digital printer and publisher located in Los Angeles is brought in to develop the material image—large-scale photographs made directly from the digital information.

2000–2002 *selfportrait.map* exhibited at the MIT List Visual Arts Center, Cambridge, MA and tours nationally.

Acknowledgments

Lilla LoCurto
William Outcault

We would like to express our gratitude to the people and institutions whose time, energy, support and affection not only carried us through the three year process of arriving at this exhibition but helped to make it a pleasure. Our appreciation to the Council for the Arts, Massachusetts Institute of Technology in Cambridge and to the Lyman Allyn Museum of Art at Connecticut College, New London, Connecticut for grants that helped to underwrite our research in the very early part of this project. Our deepest thanks to Helaine Posner and Katy Kline of the MIT List Visual Arts Center and to Charles Shepard, Director of the Lyman Allyn Museum of Art for their support and encouragement in many things, but especially on this project since its earliest inception; to Pamela Auchincloss, also there since the beginning, for her efforts in traveling this exhibition, assembling the catalog and for her friendship over the years; to Brian D. Corner Ph.D., research anthropologist at U.S. Army Natick Soldier Systems Command for his patience in scanning, uploading, transferring, converting and bearing with us while we figured things out; to Daan Strebe, computer scientist, for his many hours working with us and for the use of his cartography program *Geocart,* through which all these images have been projected; to Dr. Helaman Ferguson, mathematician and sculptor, for his initial help and all his subsequent input and humor; to Muse[x] Editions, Los Angeles for seeing us through the printing process and for their insightful and conscientious expertise on the eighteen images represented in this show. Most of all we'd like to express our indebtedness to Dr. Samuel Ferguson, mathematician, whose intelligence, perceptiveness, time and devotion gave us a new tool for exploring a three dimensional object. Sam, we can't thank you enough.

Writers' biographical notes

Helaine Posner is an independent curator living in New York. From 1991-1998, she was Curator at the MIT List Visual Arts Center, Cambridge, Massachusetts where she organized numerous exhibitions of contemporary art and wrote the accompanying catalogs. Posner is the author of a monograph on the artist Kiki Smith published in 1998 by Bulfinch Press. In 1999, she was United States Commissioner for Ann Hamilton's installation at the Venice Biennale.

David Gelernter paints, writes and teaches at Yale University in New Haven, Connecticut. He writes art criticism for the *Weekly Standard*, where he serves as art critic, and other magazines; his books include *Machine Beauty: Elegance and the Heart of Technology* and the novel *1939*.